T0131328

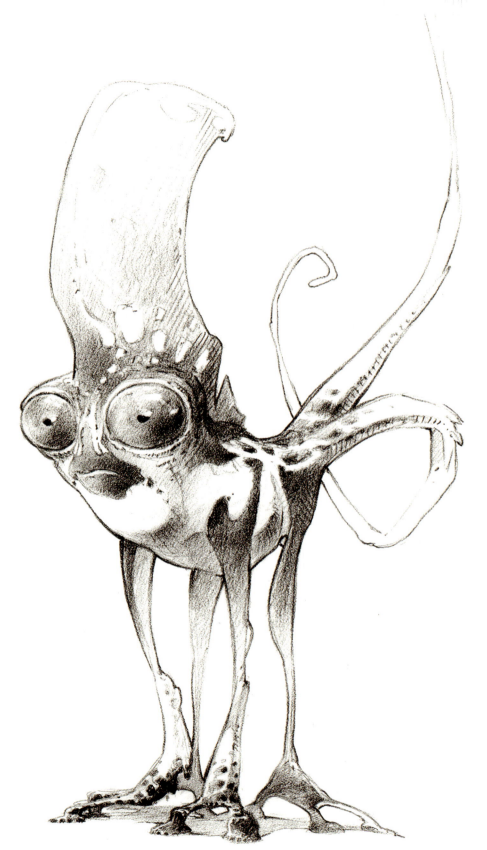

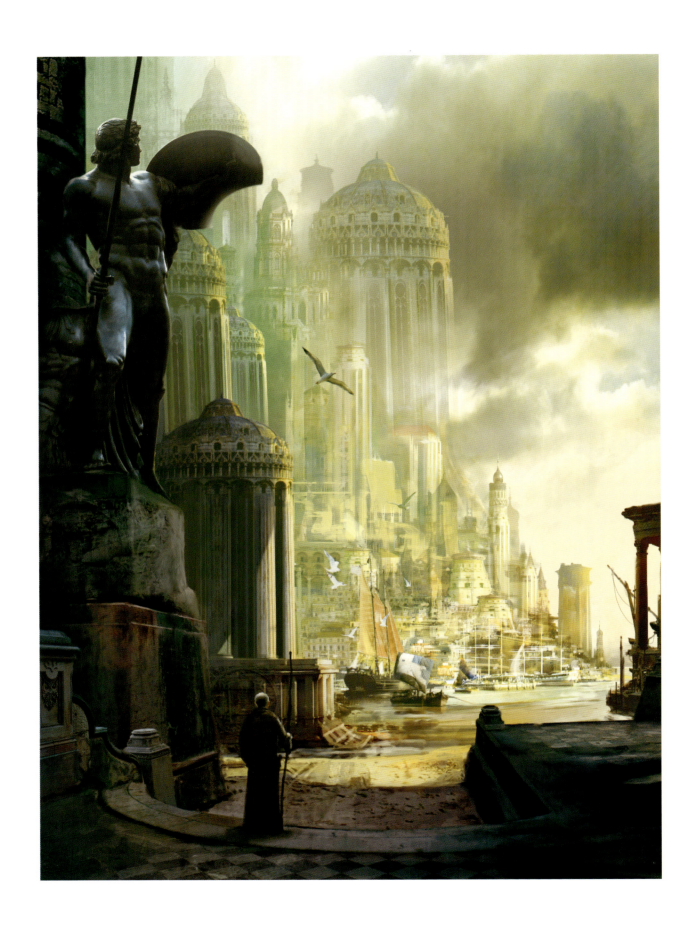

# Quantumscapes

## THE ART OF STEPHAN MARTINIERE

designstudio|PRESS

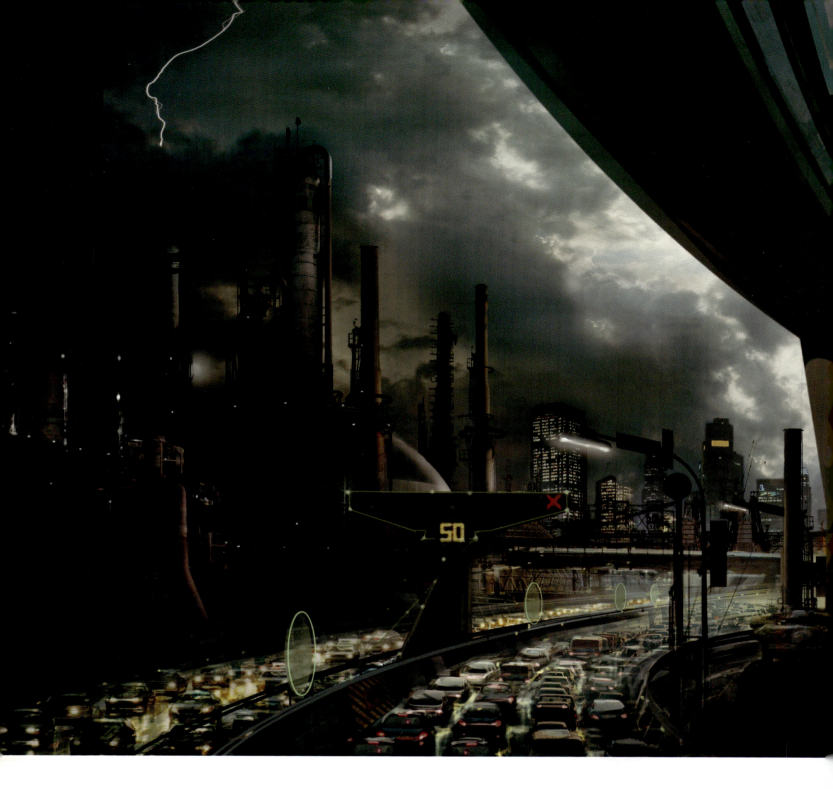

Title page image: *Shadow in Summer* (book cover) written by Brandon Sanderson
Above image: created for *National Geographic* magazine, August 2005, "Powering the Future" article.

Copyright © 2006 by Design Studio Press.
All rights reserved.

All illustrations in this book are copyright © 2006 by Stephan Martinière except as noted below.

Reproduction rights for images on pages 7, 9, 11, 68-71 are granted by Wizards of the Coast, Inc., a subsidiary of Hasbro, Inc.

Reproduction rights for images on pages 36-45 are granted by Redbear Films, Inc.

Reproduction rights for images on pages 72-81 are granted by Genesis Works.

Reproduction rights for images on pages 52, 54-67 are granted by Ubisoft-Cyan Worlds.

Reproduction rights for images on pages 46-51 are granted by Rhythm & Hues Studios.

No part of this book may be reproduced or transmitted in any form or by any means, electronic or mechanical, including photocopying, xerography, and videography recording without written permission from the publisher, Design Studio Press.

Art Direction: Scott Robertson
Layout Production: Marsha Stevenson
Text Editor: Kevin Brown

Published by Design Studio Press
8577 Higuera Street
Culver City, CA 90232
Web site: www.designstudiopress.com
E-mail: info@designstudiopress.com

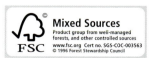

10 9 8 7 6 5 4 3 2

Printed in Korea
First edition, December 2006

Paperback ISBN 10: 1-933492-51-1
Paperback ISBN 13: 978-1-933492-51-3

Library of Congress Control Number: 2006931913

# TABLE OF CONTENTS

# dedication

To my wife Linda and my daughter Madelynn who have been so supportive, understanding and patient all these years. Thank you for making me a better artist. Thank you for making me a better person.

To my artist friends who feed my imagination and keep challenging me.

To my fans who validate my work and keep me going.

Few illustrators working in the digital realm are able to really transcend the medium and force the viewer to suppress the "How was this done?"-moment, due to the impact of the artist's vision.

Stephan is one of these artists. The richness of the visuals he presents and seductiveness of their emotionally and texturally elaborate presentation is due in part to his classical training and ability to work in any medium. The other part is Stephan's talent and ideas.

Stephan and I worked on a project called *Planet Ice* when both of us made our first steps into the digital realm.

I have followed his artistic journey since then and seen with joy how Stephan's passion for the subject and perseverance in continuously learning new means of expressing ideas developed into his current range and style. Not only is it an ongoing joy for me, but for anyone who appreciates the worlds of ideas in visual arts and entertainment.

I hope more books of his will follow and wish Stephan all the best for continuing his explorations of amazing worlds of imagination.

Ad astra,
Oliver Scholl, Production Designer
*(The Time Machine, Godzilla, Independence Day)*
Tokyo, 05.24.06

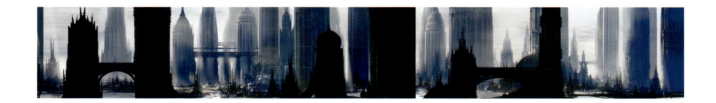

I'll never forget the first time I had the pleasure of viewing Stephan's work. It was back in the late 1980s and I was the art director on a motion-based ride film. The film was CG and it was an ambitious project—yet the medium was still relatively young. We needed to maximize the budget by capturing the most information possible in every piece of production art that would be heading into the pipeline. Only then would we get the best-possible result with the time and money we had to accomplish the job. We were looking for an artist that was not only a solid designer but one who also understood cinematic composition and dramatic lighting. There were a few great artists on the project already but we needed a few more. The pressure was on.

One day in the heat of production, a PA mentioned to me that he would be bringing by Stephan's portfolio. I was excited to see the work because Stephan had come highly recommended through friends in the television animation business. When his portfolio arrived I anxiously started flipping through it. I hadn't been getting much sleep and I admit that I was growing more confused with each page I turned. I was convinced that the production assistant had scrambled at least two, or possibly three, different artist's portfolios together and now I wasn't sure whose work I was looking at.

The body of work I was viewing represented a wide diversity of subject matter and styles, yet each style was accomplished with that rare excellence that only comes by way of seasoned experience. This added to my confusion, because I had heard Stephan was a relatively young guy. With so many of the pieces coming from such distinctively different genres I was having a hard time believing that a young artist had attained such competence across such a wide range.

There were many character designs of a classically animated nature. These were vibrant and full of charm and seemingly manifested with ease. It was clear to see that the artist enjoyed the process and pursued the work with a light heart and whimsical sense of humor.

Then there was the abundance of creatures and aliens that were fully detailed and demonstrated the anatomical excellence necessary for AAA visual-effects production. Yet these images felt like they came from the twisted thoughts of someone with a much darker nature. These images suggested the artist spent a great deal of time submerged in the highly detailed worlds within his own rather serious mind. These had not a trace of the comical personality that had created the previous characters that children would adore.

The environmental designs transcended an equally impressive range. There were backgrounds of creative originality for the Saturday Morning market that seemed above and beyond what was necessary for the audience, yet these were alongside brutally aged environments and majestic architecture from a future age that would make even the best sci-fi directors salivate. Some seemed so fascist and overbearing that they were intimidating.

Then there were his vehicles and robots and weapons and fashion designs. His ability to solve organic challenges equaled his tenacity for solving those of the more mechanical nature. His ability to inject emotionally expressive believability into his character creations was as consistent and inspiring as his ability to convince us that his sprawling cities must contain libraries filled with volumes of their history.

By the time I was convinced that this body of work was actually created by one individual, I knew that I was going to meet an artist that would soon be recognized throughout the world. He was one of those very rare talents that would

one day enable me to brag, "I knew him when..." In the meantime, I told my producer, "We need him now!" Needless to say, I was blown away.

To my dismay, he was too busy to work on our project at that time, but I knew to keep a sharp eye out for Stephan Martinière from that day forward.

Shortly after that, Stephan embraced the computer as a tool for his craft. It was exciting to witness because it enabled him to manifest his imagination to an even greater degree. With this new tool in hand he pushed himself further and harder, and in the course of his tireless efforts he has managed to define a body of work that has come to be recognized by artists and designers across the globe. His passion for brilliantly structured, incredibly detailed, and awe-inspiring, neo-industrial landscapes has defined a fresh visionary signature that is his alone. Much like the great Syd Mead and Ralph McQuarrie before him, we know Stephan's worlds when we see them.

Stephan has become a major inspirational force for many young artists and designers today, yet few would know that his personal being might also serve well as a role model. In the course of achieving excellence, Stephan has managed to retain the heart of a child and the humility of the student who is forever striving to better himself with every project that he takes on. He exercises his skills with the faith that his worlds can always be pushed to new levels and explore new boundaries. It's no wonder that his creations continue to amaze the many film directors, game designers, novelists and publishers that seek out his talent with the hopes of adding his unique vision to their projects.

With this second book, Stephan once again gives us the long awaited opportunity to be inspired by his more recent works and enable us that brief vacation into the landscapes of his otherworldly mind. We can only hope that he won't take nearly as long to release the next one.

Yet another humble fan,
Lorne Lanning
Creator of *Oddworld*

**Quantumscapes** is the second book in the **Quantum** series. It showcases a new collection of book covers and publishing works done over the last three years, as well as film concepts, video, and card-game illustrations. Unlike **Quantum Dreams**, which was primarily a collection of cityscapes and environments, **Quantumscapes** features a lot of creature concepts for commercials, games, and film projects. Creature design is something I enjoy as much as doing environments. They both share a visual language used to communicate a story or an emotion. They both share and explore distinctive shapes and unique or exaggerated features to create various personalities. They both demand calculated compositions of many different elements to create one object or an environment and the color and mood applied to it. A repulsive or frightening beast, an amusing, sophisticated alien, a dark city imbued with sorrow, or a quiet and mysterious jungle. All the components of this visual language, when carefully applied, can trigger strong or subtle emotional responses. It's always a challenging and exciting process. It's also extremely rewarding when the work connects to the viewer, when the intended emotional response shifts and branches out to other emotions and creates a stronger resonance.

This book also showcases a collection of drawings done for the video game **Heaven**. These drawings are done in a different style from my paintings or sketches but they are part of my eclectic and artistic palette. Art Nouveau, Neo-Classic, and the Sullivan School are among my favorite architectural periods. Alphonse Mucha, Otto Wagner, Charles Rennie Mackintosh, and Louis Sullivan are some of my favorite artists. I find their styles elegant, precise, inspiring, and beautiful. The **Heaven** project gave me a great and unique opportunity to explore and visualize heaven "à la Martinière" with a collective of masters guiding my thoughts and my pencil.

This book also includes concepts and illustrations for the video game **Myst 5**. These concepts were originally conceived for the game **Uru: Ages Beyond Myst**. At the time, the project was going to be a massively multiplayer, online role-playing game—but financial necessities decided otherwise. The illustrations remain similar in feel and style to the ones showcased in **Quantum Dreams**, but there is also a collection of sketches. My role as visual design director for **Myst 5** was comprehensive—and creatively, very rewarding. Creating an environment, a device, or a creature is exciting. However, creating many worlds populated with various strange creatures and mysterious machines, all unique and

### awards

**2006**
- The Chesley Award for Best Book Cover
- The Grand Master Award: Exposé 4
- The Excellence Award for Cityscapes: Exposé 4
- The Into the Pixel Award: E3

**2005**
- The Master Award for Character in Action: Exposé 3
- The Excellence Award for Transport: Exposé 3
- The Excellence Award for Transport: Exposé 3
- The Excellence Award for Transport: Exposé 3
- The Excellence Award for Cityscapes: Exposé 3
- The Excellence Award for Cityscapes: Exposé 3
- Into the Pixel Award: E3

**2004**
- The Master Award for Environment: Exposé 2
- The Master Award for Transport: Exposé 2
- The Excellence Award for Best Book Cover
- The Seattle Show Award
- The Gold Award for Best Comic Book Cover: Spectrum

**2001**
- The Thea Award for Best Attraction

**1997**
- The Silver Award for Editorial: Spectrum

all connected to an overarching tale is truly exhilarating. It's like creating a visual web: constantly radiating and branching out in many directions, but at the same time never losing sight of the center. It was a fabulous experience and I will cherish these years working with Rand Miller at Cyan.

Also in this book are concepts done for the trading card game *Magic: The Gathering: Ravnica: City of Guilds*. These illustrations were done for the boxes and the cards. The cards were conceived with an especially fast approach. Due to the very small size of each card, I wanted to explore a quick—yet effective—way to realize each painting.

The book also contains other creature concepts designed for commercials and films. These ideas are usually done quickly. Doing concepts in a limited amount of time is really effective; it forces me to think fast and extract what is essential to each idea almost instinctively. The distinctive elements necessary to shape the creature and its personality, its pose, scale, color and proportion have to be drawn from a practiced and understood visual language. There are always multiple possibilities, but as these visual elements are drawn and rearranged in a series of exploratory thumbnails one particular idea will emerge as the more effective one. Of course, it is always interesting to notice that what I would think of as the best or more interesting idea might not be the one the client would choose. Concept design is also about patience with a pinch of Zen. Regardless of occasional bumps along the way, being a visual artist is a calling. It is something you embrace wholeheartedly. It's something I know I will continue doing until my finger can no longer hold a pencil… but then surely I will find a way to use my feet.

Stephan Martinière
July 2006

## contact info

Stephan Martinière can be reached by email at: *martiniere@comcast.net*

To see more of Stephan's work visit: *www.martiniere.com*

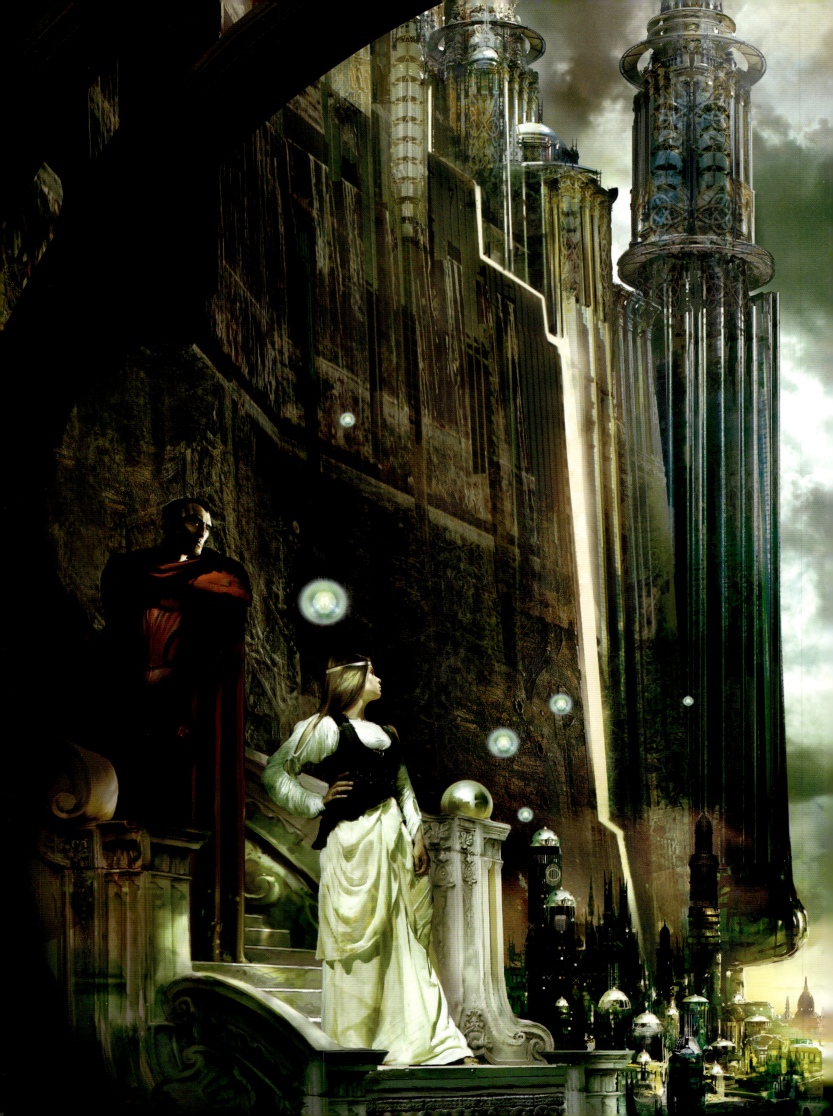

"The artist is nothing without the gift, but the gift is nothing without work."

—Emile Zola

ELANTRIS

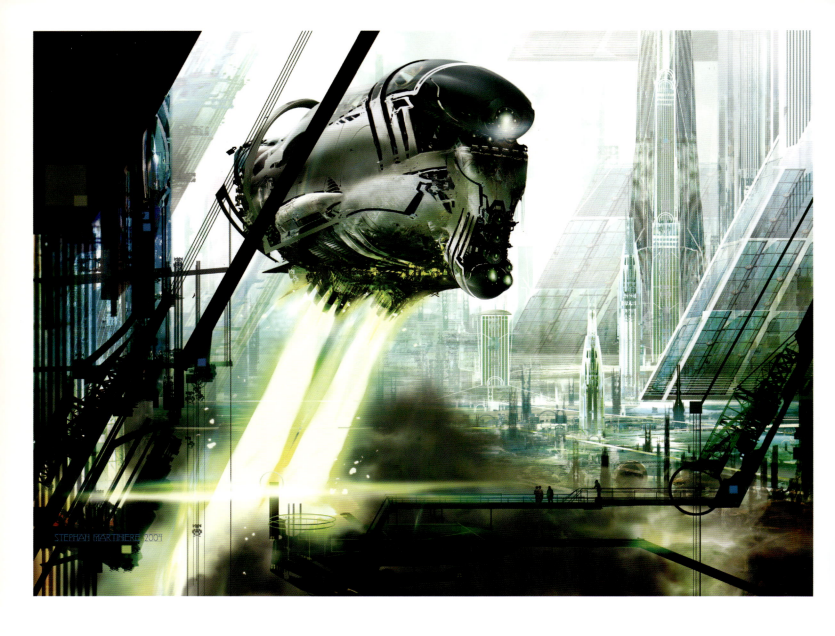

## UTOPIALES (above)

poster | Nantes Science-Fiction Festival (France)

Photoshop is a great tool; it allows me to remanipulate objects and explore alternate ideas. I liked the ship I originally created for *Probability Sun*, but once it was finished, I wanted to do a beefier version of it. The poster for *Utopiales* gave me that opportunity. I wanted this poster to have a graphic quality, something that would be understood instantly. It was very striking to see it printed on a giant billboard as I exited the airport in France.

## PROBABILITY SUN (opposite)

book cover | written by Nancy Kress

This is the second book in a trilogy, after *Probability Moon*. A spaceship retrieves an ancient alien artifact from a mountain. The look of old locomotives was my inspiration when I did this painting; ever since I was little they've always reminded me of giant, black, metal bugs.

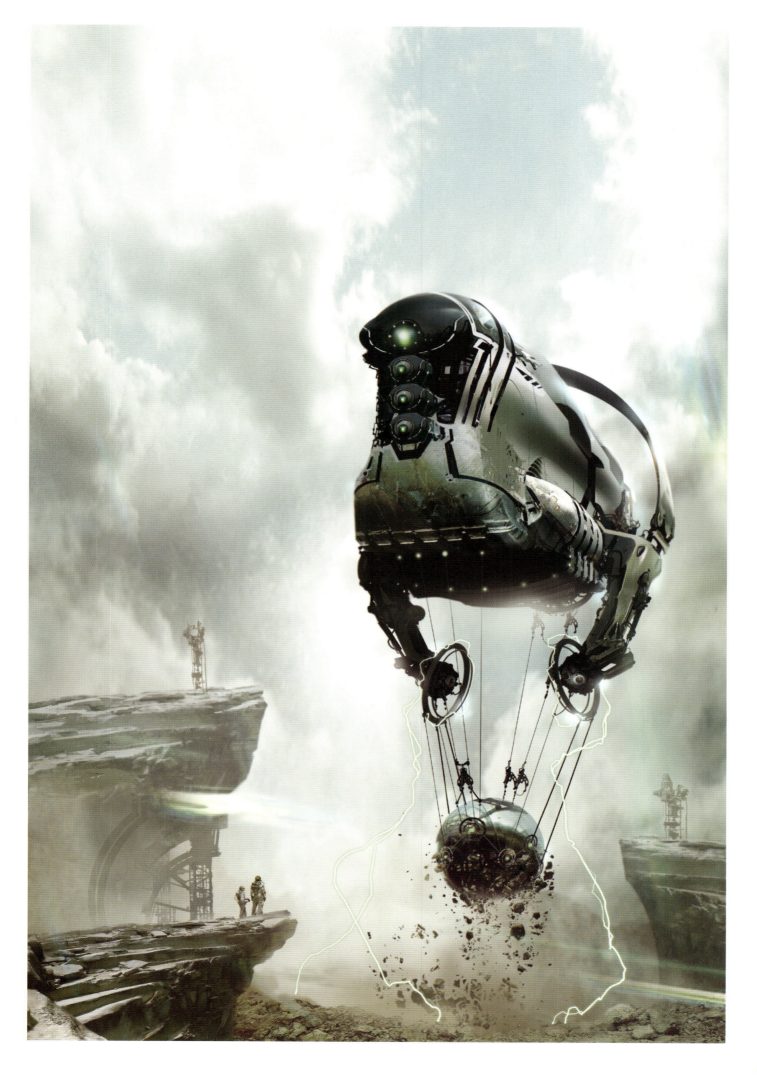

# NAUTILUS

**personal project**

I wanted to explore an environment reminiscent of an aquatic setting. How would an underwater species evolve out of its environment and still retain some of its aquatic design, say, a thousand years in the future? The process of doing this painting was spontaneous; I let the colors and shapes dictate the next step. I also wanted the elements to remind the viewer of specific organisms such as the nautilus, the fan-shaped sponge, or the jellyfish.

*(above detail)* I particularly enjoyed doing the structures in the distance. They rise in an intricate assembly of very thin white blades and curves that resemble fish skulls. They have a certain elegance and lightness that seem to defy gravity.

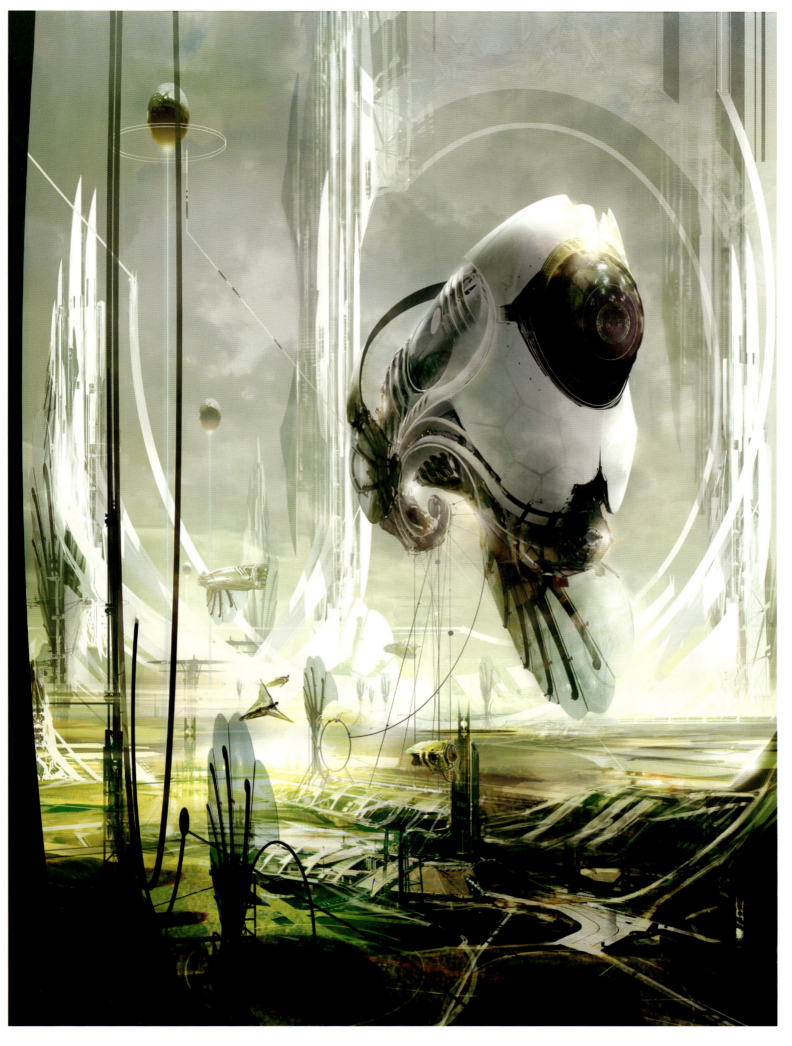

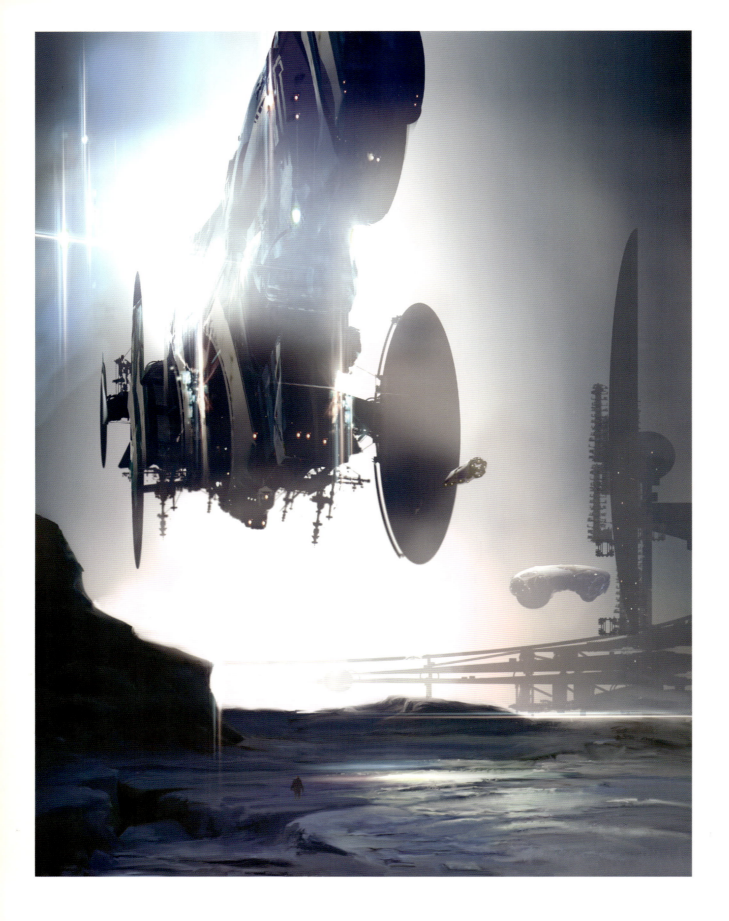

## AGAINST A DARK BACKGROUND *(above)*

**book cover** | *written by Iain M. Banks*

The idea was to do an enormous spaceship landing on the shore of a frozen sea at night. I wanted to do something moody and suggestive. I like the simplicity of the painting. However, the cover was eventually rejected for being too cold.

## THE DRACO TAVERN *(opposite)*

**book cover** | *written by Larry Niven*

This painting depicts a tavern in the middle of a Siberian landscape that is a gathering place for aliens of various species. It was my inspiration for *Against a Dark Background*. I took a painterly approach to this painting.

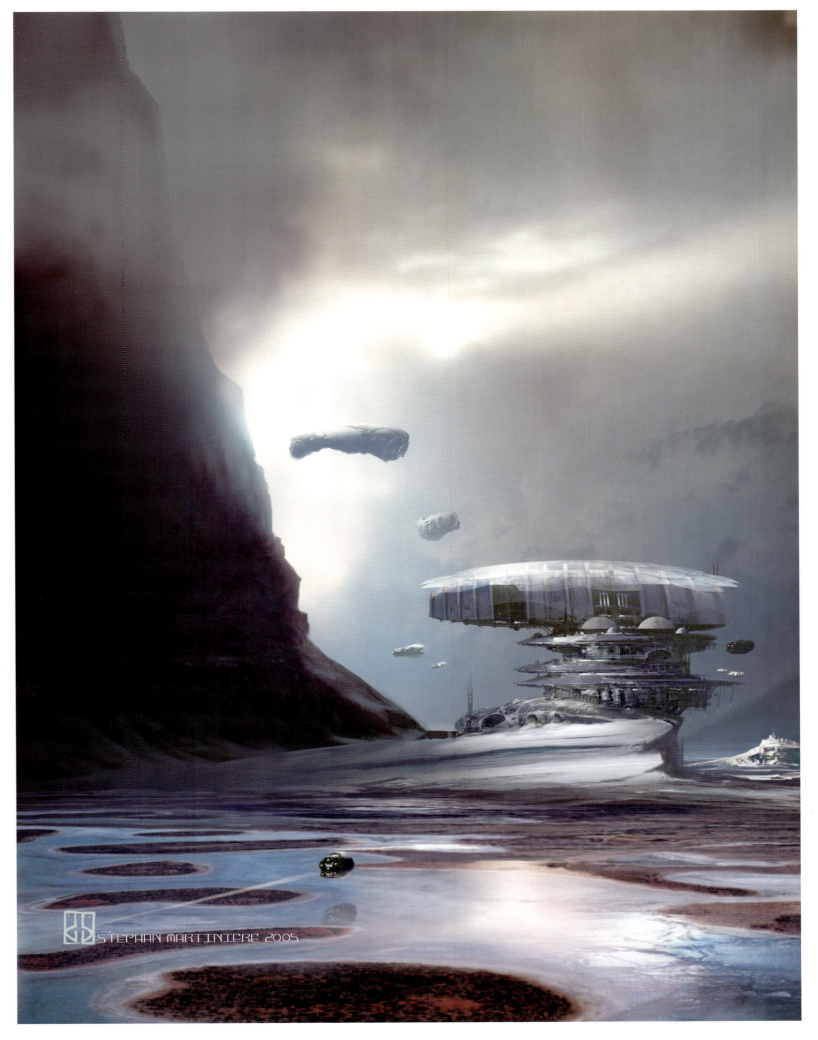

STEPHAN MARTINIERE 2005

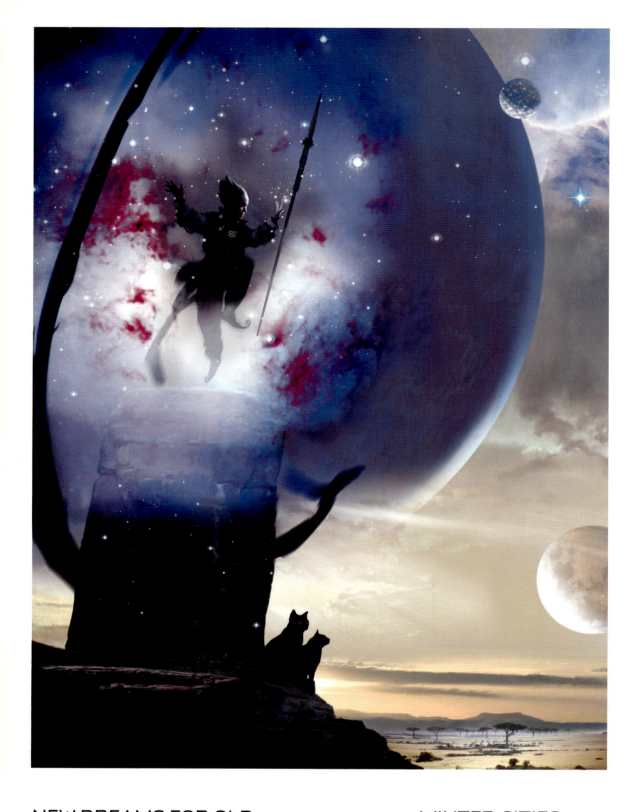

## NEW DREAMS FOR OLD (above)

**book cover** | written by Mike Resnick

This is a stretch from what I usually do. This book is a compilation of stories and I wanted to see if I could bring many of the different visual elements of each story into one cohesive scene. The end result has a very dreamlike quality.

## WINTER CITIES (opposite)

**book cover** | written by Daniel Abraham

This was the second book of the *Long Price Quartet*. The first book, *A Shadow in Summer*, had a very warm and yellow palette. Winter Cities brings the characters to an industrial town set in the snow-topped mountains. Since it is set in winter I decided to use a bluish and cool palette. The book describes several enormous towers shadowing the industrial town, with smoke stacks protruding everywhere. The first images that came to my mind as I was reading the description was of steel factories. The next step was to try to integrate that visual with a medieval-fantasy flavor. I spent a lot of time playing and exploring with various architectural custom brushes. The city at the center has a very impressionistic feel.

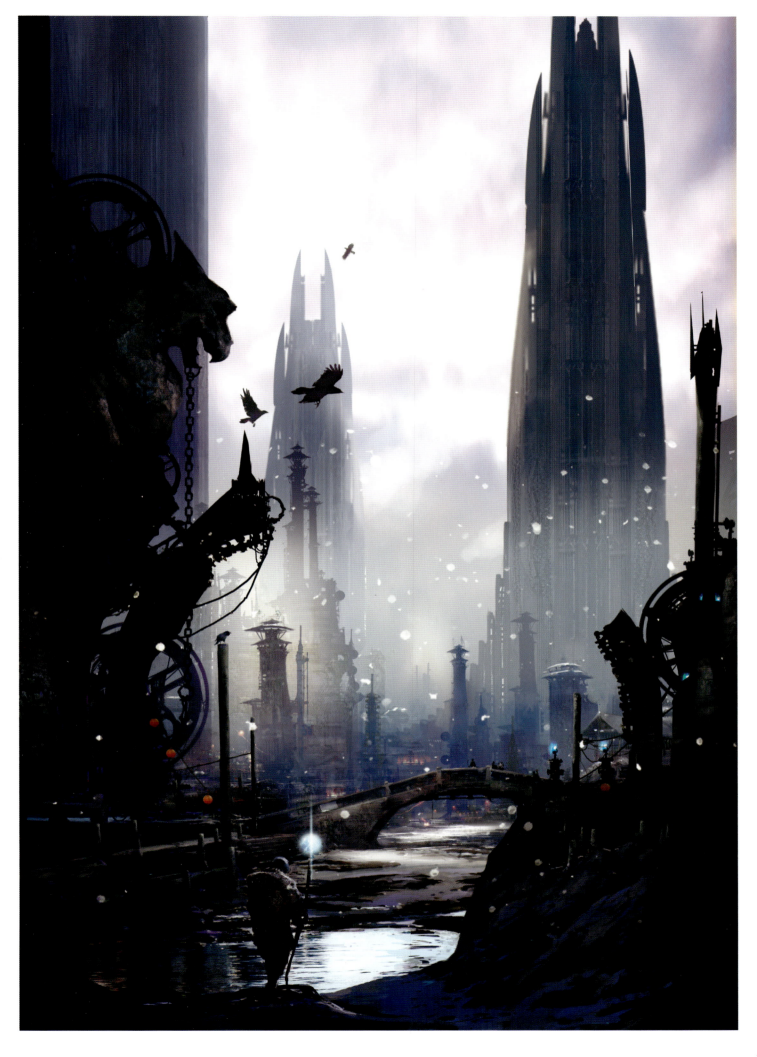

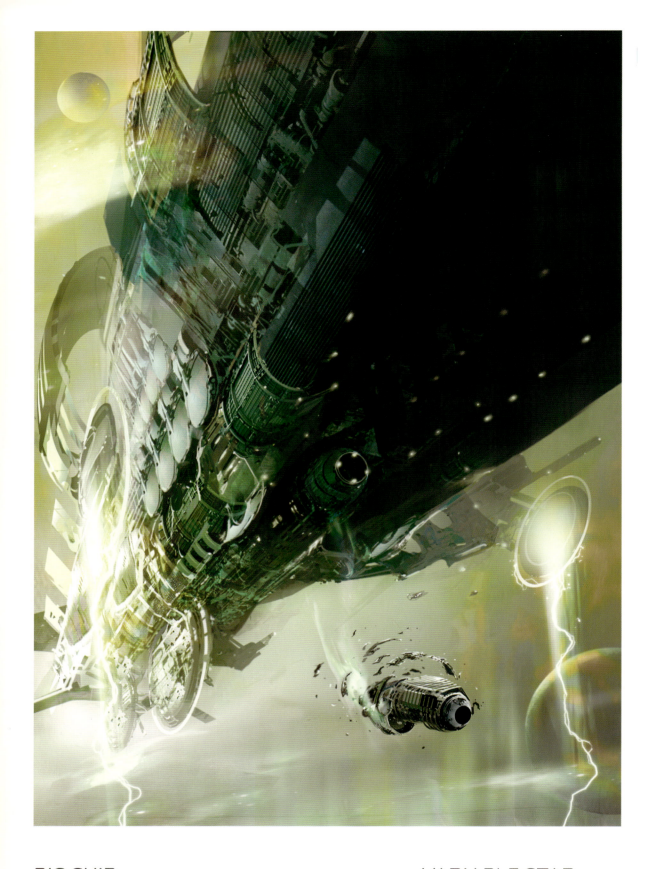

## BIG SHIP *(above)*

**book cover** | written by Charles Strauss

I wanted to depart from the typical dark blue or black color of space. Placing the enormous space ship in a nebulous cloud would allow me to have better control of the depth. Adding haze allows for the color to gradually vanish into the distance, thus giving the ship a bigger scale. The upshot angle was important too. I wanted the ship to be imposing and block the top two-thirds of the painting with lightning bolts blocking both the left and the right.

## VARIABLE STAR *(opposite)*

**book cover** | written by Robert Heinlein & Spider Robinson

A young man runs away from wealth and power to seek his fortune in space. I had never done a painting using such a strong yellow palette. Interestingly, in the beginning, the color palette was less saturated. I spent more time than usual for this piece; I wanted to really play with suggestive and impressionistic shapes and colors. The area in the distance, for example, feels very detailed, however it is actually quite simple.

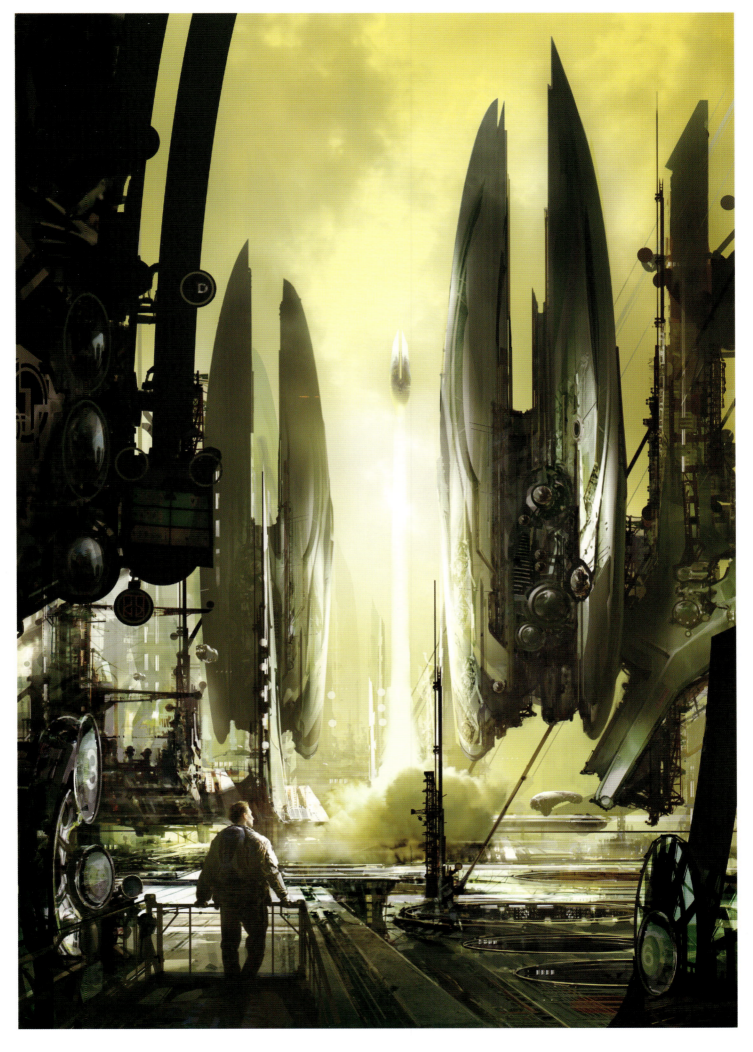

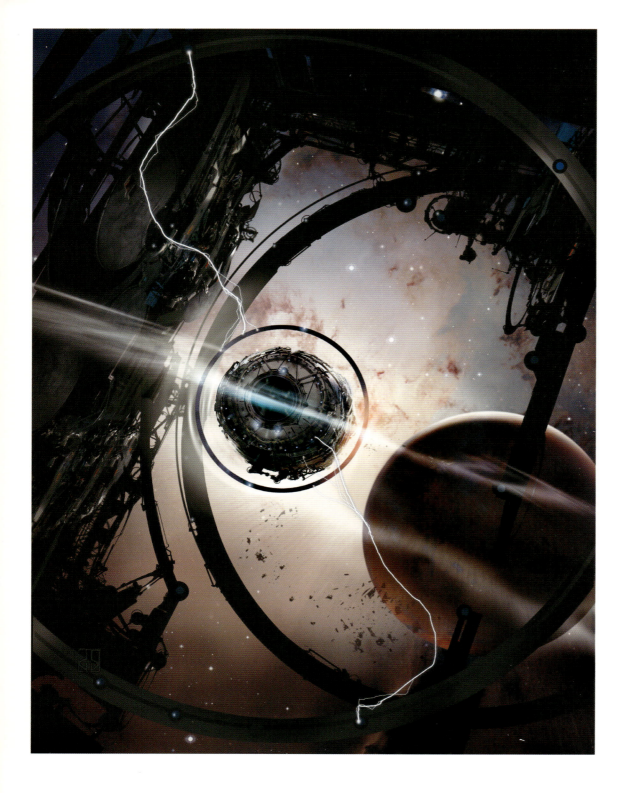

## PANDORA'S STAR *(above)*

**book cover** | written by Peter F. Hamilton

This painting is of a gate in space to a strange planet. It has a very graphic composition; the two circles are the focal points. The eye goes to the ship, then to the planet, then back to the ship. Sometimes simple compositions can be very effective.

## MARROW-LE GRAND VAISSEAU *(opposite)*

**book cover** | written by Robert Reeve

The idea behind this was to design a spaceship the size of the entire solar system. It was quite a challenge; I had never done a ship that big before. One thing that helped was to use very low color contrast for the ship, thus setting it in the distance right away. The next trick was to indicate that some elements of the ship are bigger in the distance and have less detail visible. I wanted these elements to read as silhouettes. The small planets are very important in establishing the scale. They must have more color contrast, no matter how small they are in the distance, always telling the viewer that they are in front of the ship. Then the sun was placed beyond the smaller planets but still in front of the ship, finally achieving its enormous scale.

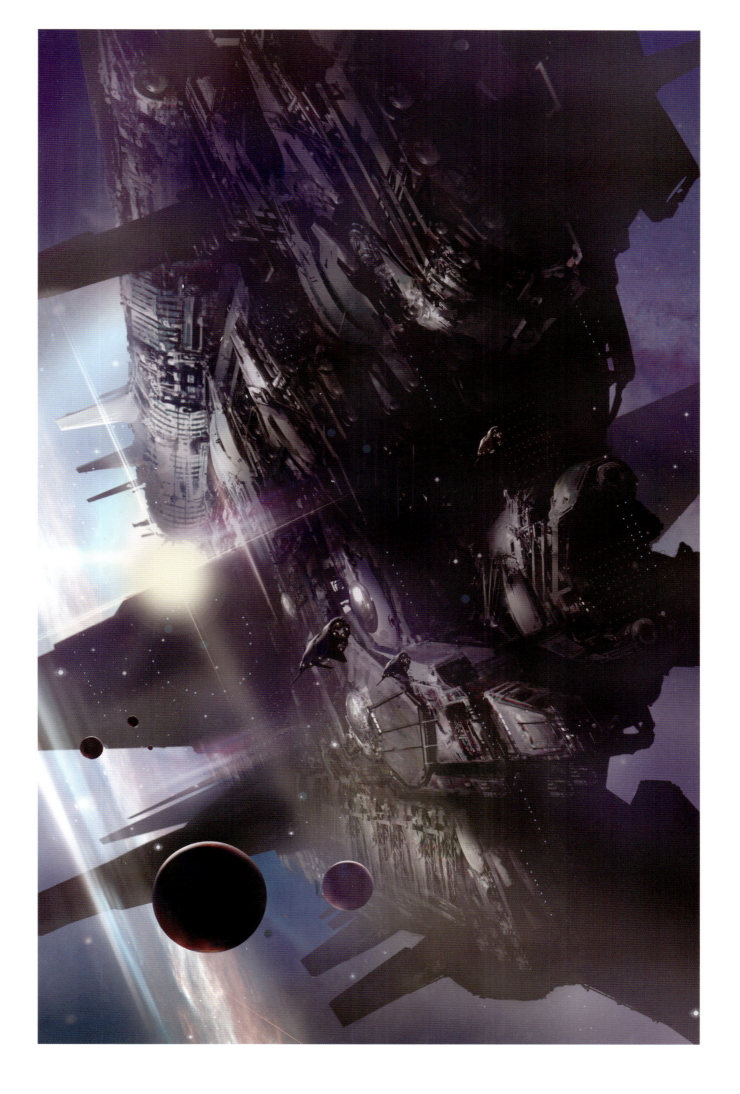

## RAINBOWS END (above)

**book cover** | written by Vernor Vinge

I had fun doing this painting. The book is a Next-Gen techno-thriller about a near-future techno world where you can wear lenses that allow you to see the world around you the way you wish it to be. There is a rabbit character not unlike the one in *Alice in Wonderland* and I kept thinking about the chase down the rabbit hole to an imaginary world—this one being a virtual one. I thought the use of pink and bluish color would work well to convey a dreamlike feel. I found it interesting how the bunny wearing the tuxedo changes the entire vibe of the painting.

## BRAZYL (opposite)

**book cover** | written by Ian McDonald

*Brazyl* is about Brazil in the future. It's all about sex, corruption, drugs, power, religion, and pretty much everything else. My first inspirations were of the cities that never sleep: Vegas, New York, Tokyo, etc. One way to convey all these attributes without being over the top was to use neon signs. It was very effective because these signs also added color elements to the painting. It was unintentional, but in the end the color palette reminded me of Syd Mead's paintings for *Blade Runner*.

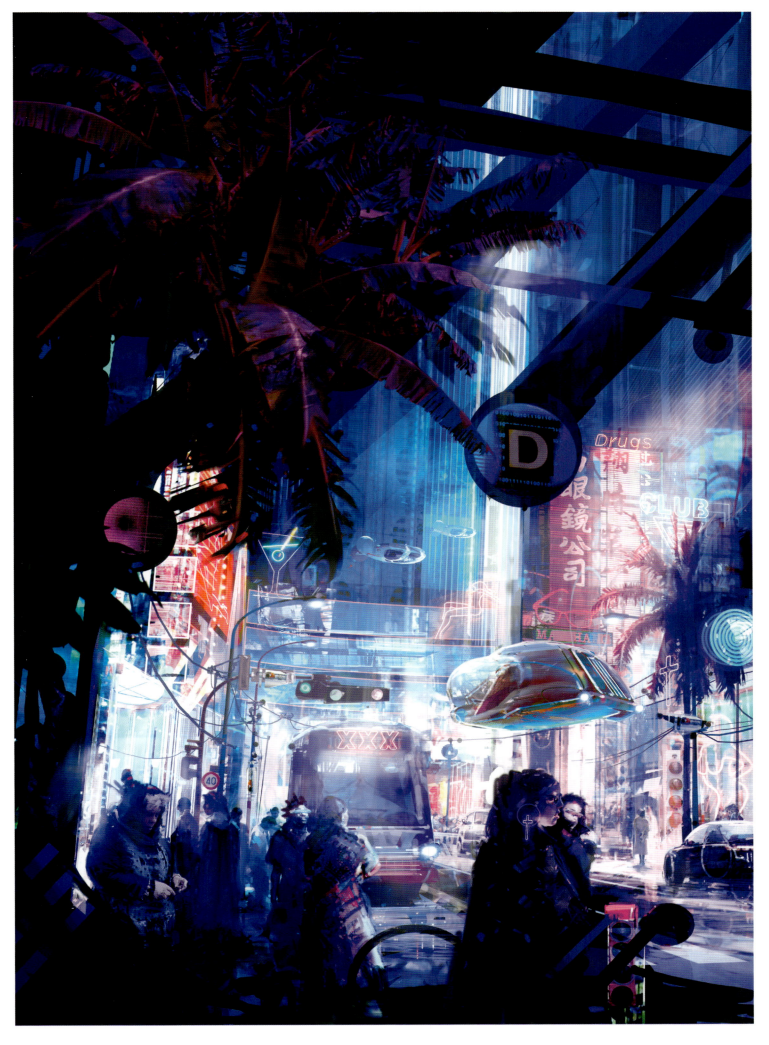

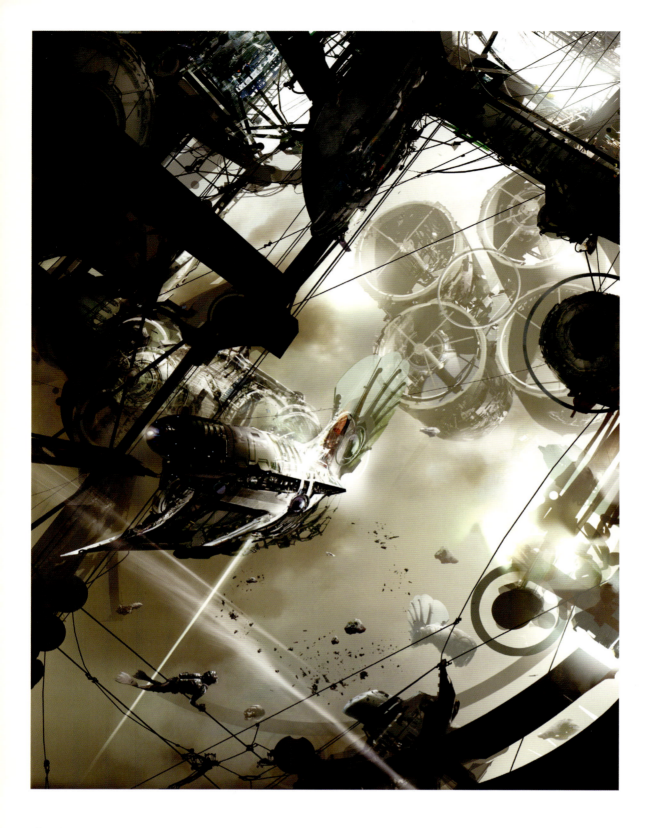

## SUN OF SUNS (above)

**book cover** | written by Karl Schroeder

This is a swashbuckling adventure in a world of manufactured suns and nations that build their own worlds out of wood and metal and spin them for gravity. This is a compelling environment with an industrial-punk flavor. I reused many existing elements from previous paintings for this illustration. I feel that the top of the painting is the most interesting; I wanted to convey a feeling of backlighting and silhouettes.

## RIVER OF GODS (opposite)

**book cover** | written by Ian McDonald

I like the composition for this painting. The world depicted in the book is very similar to the one in *Brazyl*, but takes place in India. There is a strong division between the wealthy and the poor classes in the story. To convey that, I decided to use visual contrasts—both colors and different elements. These visual contrasts include using light colors for the upper part of the city and darker colors for the lower part, as well as organized and artificial elements with a dominance of vertical lines on the upper part against crowded organic mass in the lower section of the painting.

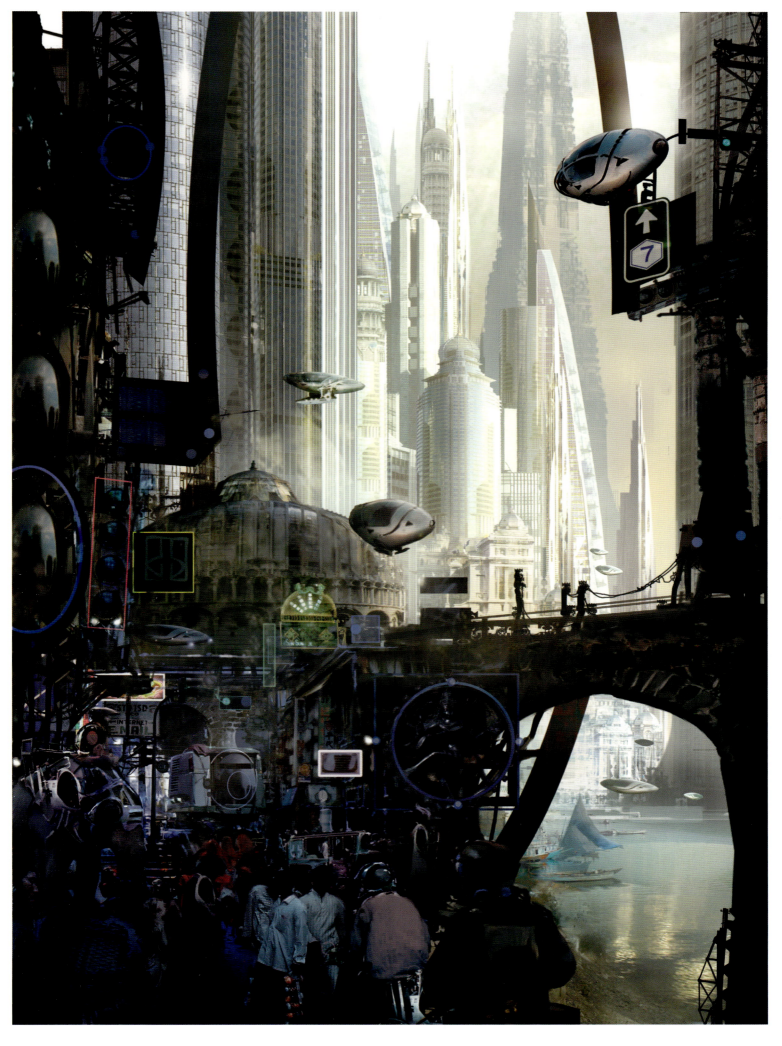

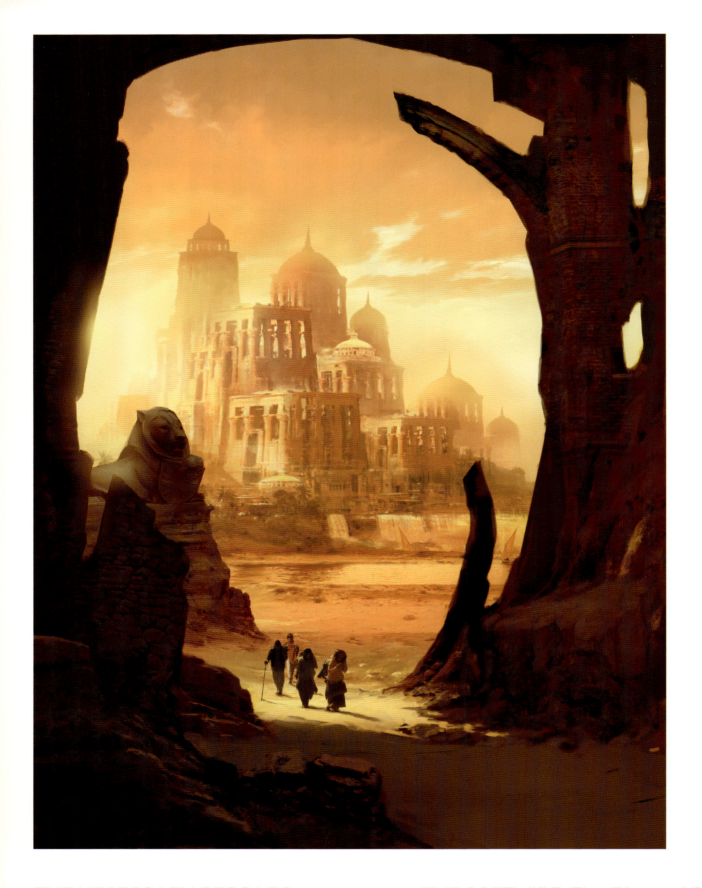

## THE NECESSARY BEGGARS *(above)*

**book cover** | written by Susan Palwick

The art director for this project called me one day and asked me for a favor: could I do this painting and finish it "yesterday?" I finished it in one day; all the pieces seemed to fall into place. Choosing a monochromatic palette was a large part of the solution, along with keeping the perspective simple and the foreground loose and painterly.

## THE SOFTWIRE: The Rings of Orbis *(opposite)*

**book cover** | written by P.J. Haarsma

I was initially asked by the author to conceptualize the alien characters of this story for a movie project. When the offer to do the cover for the first book came, I already had half the work done. I was given some specific guidelines for the layout of the jacket, making the assignment even easier. I was very pleased with the painting treatment on the aliens on the platform, despite their small size.

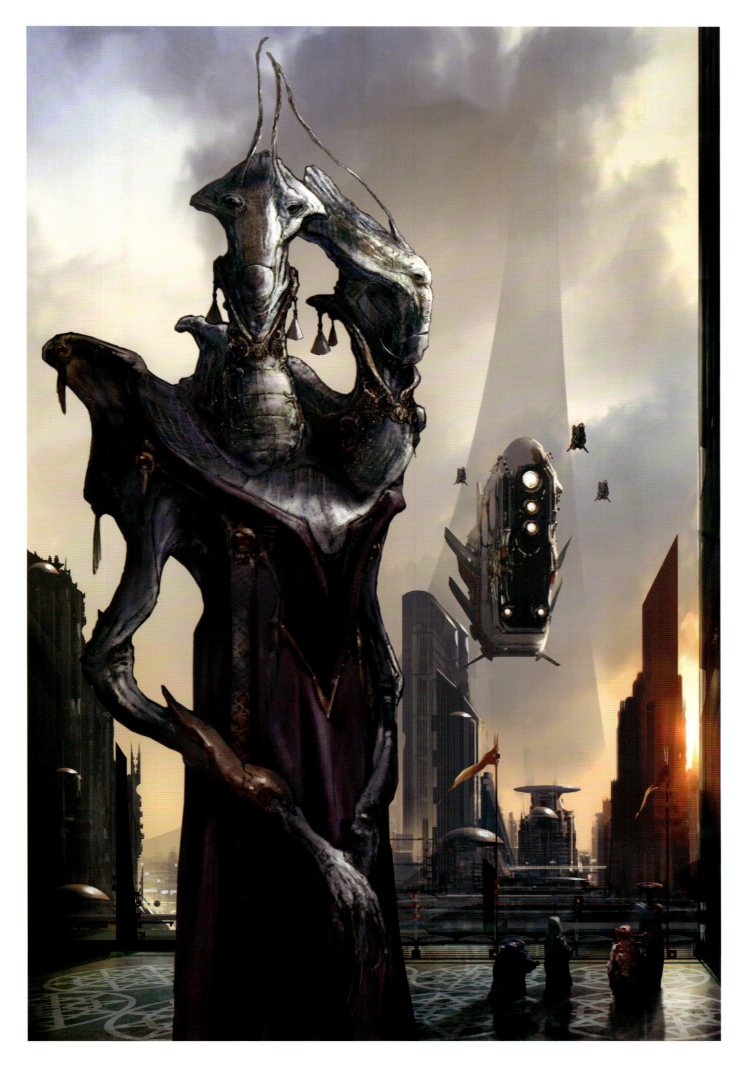

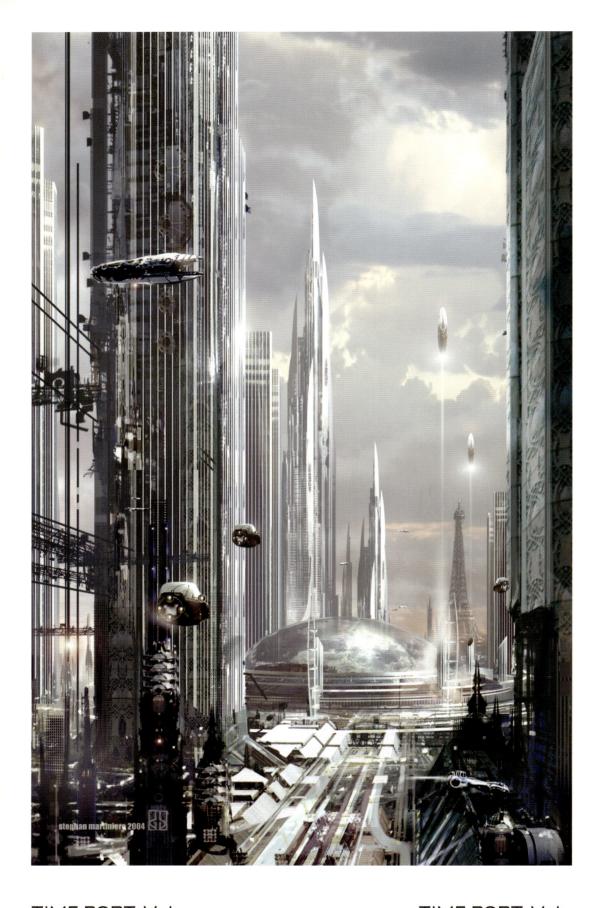

## TIME PORT: Volume 1 *(above)*

**book cover** | written by Kevin Bokeili

This book depicts Paris in the future. The idea behind this cover was to reuse and modify an existing painting called *Angel City*. I had the opportunity to revisit some of the architecture and explore some variations. The tower on the left is actually more satisfying than the original; it has more structure and a cleaner, more elegant design.

## TIME PORT: Volume 2 *(opposite)*

**book cover** | written by Kevin Bokeili

In Bokeili's futuristic world, people can take vacations in any time period in the past. Time-pods similar to the one in the center are taking off from the time port on the left painting. I think the chrome effect achieved on the pods and the launch pads turned out quite well.

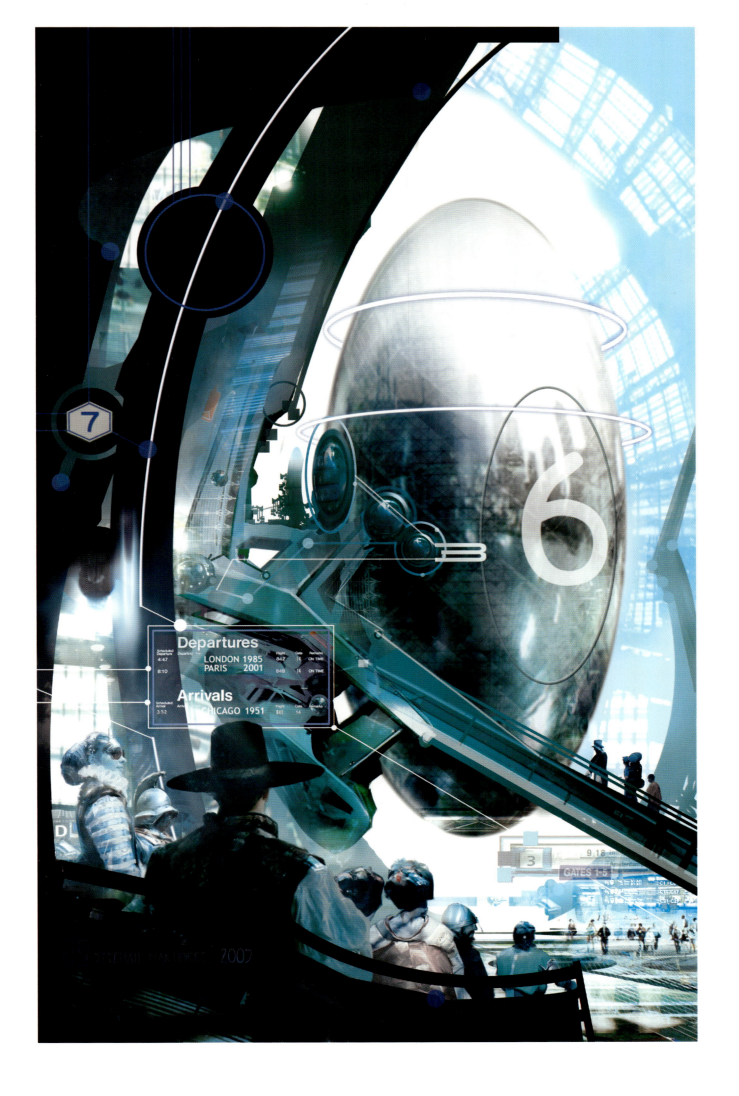

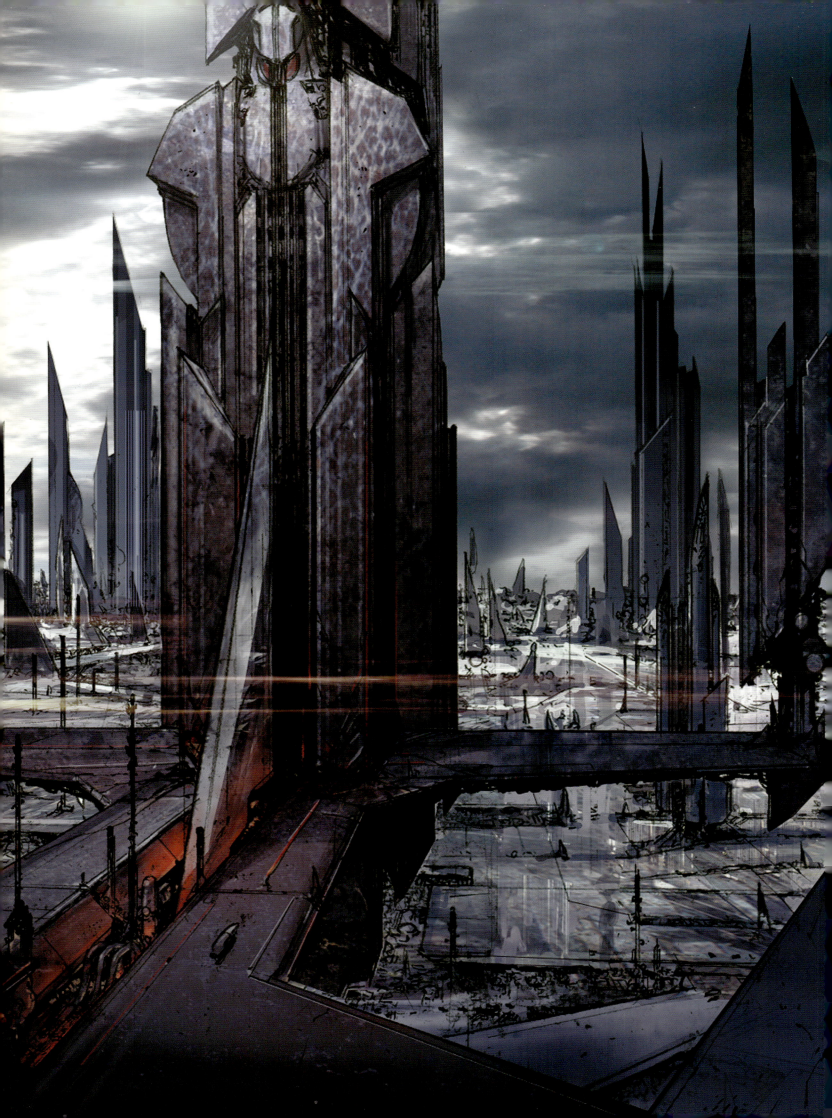

# chapter two | film & commercial work

"He who works with his hands is a laborer. He who works with his hands and his head is a craftsman. He who works with his hands and his head and his heart is an artist."

—*St Francis of Assisi*

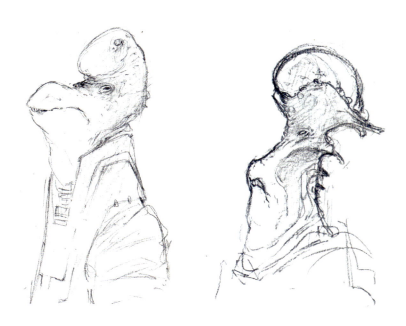

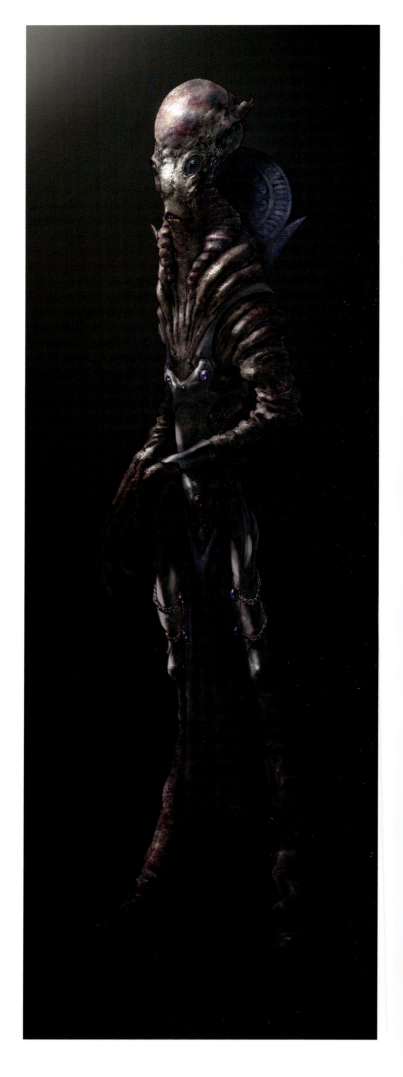

# CIRROAN & BOOHRAL

**feature-film alien concepts** | The Softwire

*(above)* The Softwire is both a movie project and a series of books. I was free to use my imagination when designing these creatures. Cirroans are an incredibly intelligent race, entirely dedicated to science. They have a large, fleshy bubble that takes up most of their forehead that is used to convey their emotions.

*(opposite)* The interesting part of doing creature concepts is manipulating familiar anatomical elements in such a way that they can convey a certain emotional response. Here the challenge was not to create a "never-before-seen" creature, but was more about creating humanoid aliens with recognizable features.

Boohral is the name of a Trefaldoor, another species of alien. He is very large with a small head. He uses an external brain attached by numerous wires. Boohral is powerful and respected, smart and aggressive. My inspiration came from creatures like the grouper and the toad; I wanted him to look both menacing and slightly dumb.

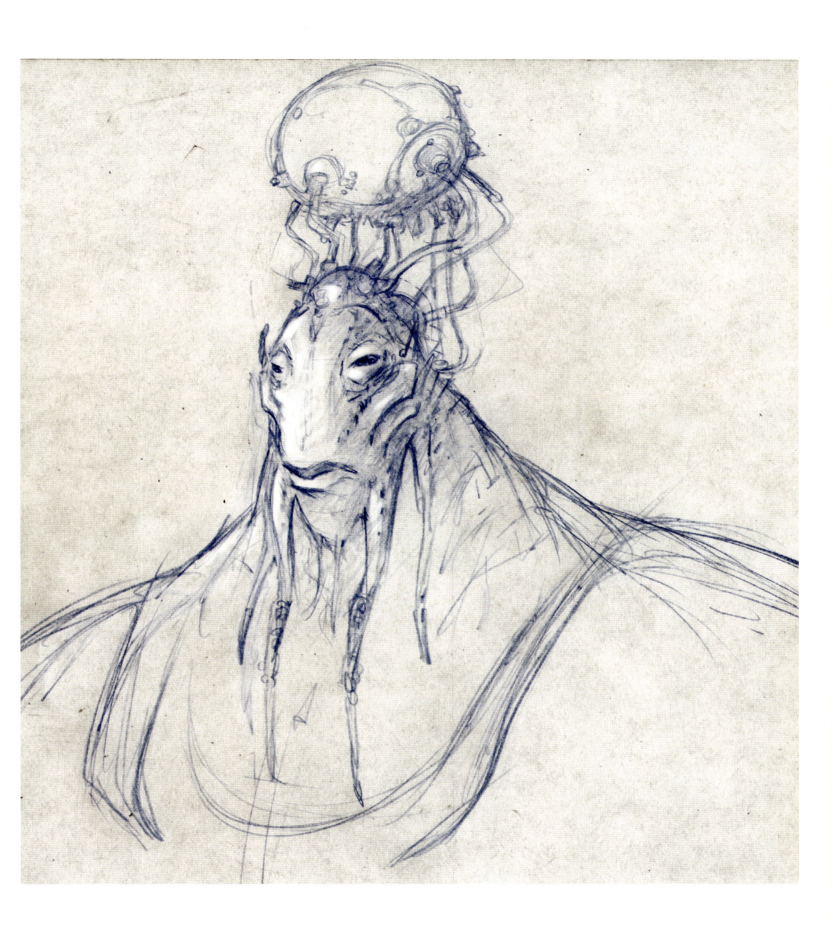

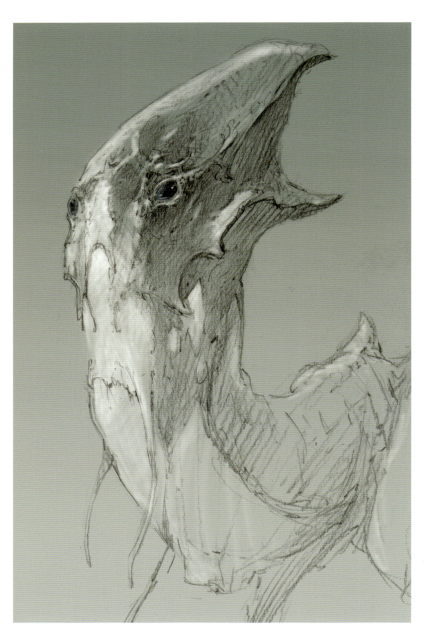

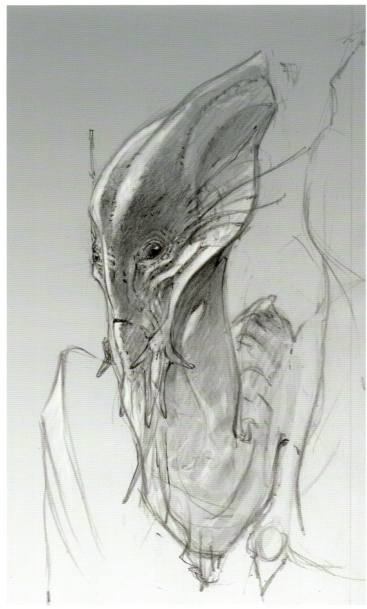

# KEEPERS

**feature-film alien concepts** | The Softwire

Keepers have two heads. They are regal leaders, both noble and kind. I wanted to give their faces a very wise, ancient look, something similar to the face of an old iguana. Their transparent, blue skin also conveys that feeling of old.

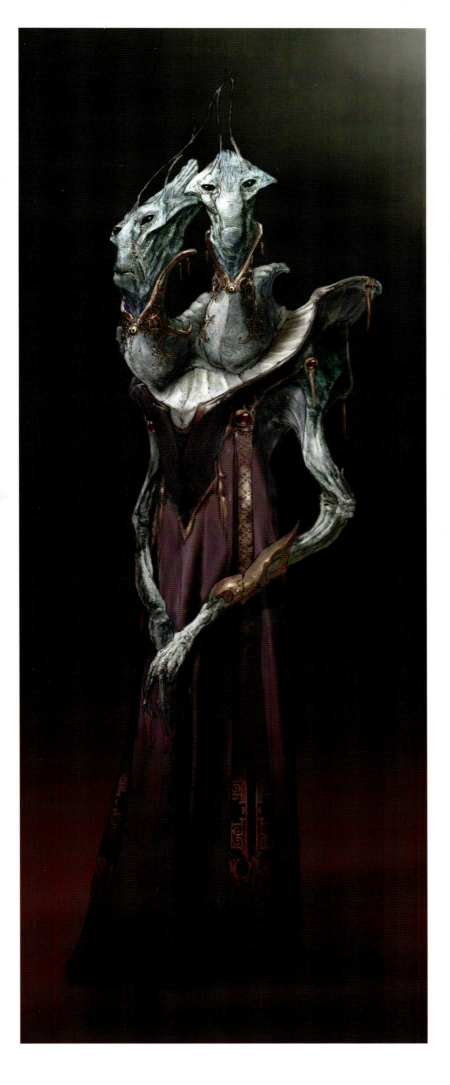

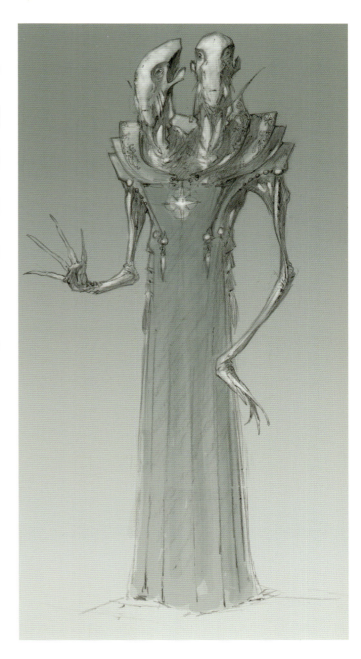

# NEEWALKER

**feature-film alien concepts** | The Softwire

Neewalkers are aggressive and creepy alien creatures, half-humanoid and half-machine. They have fish-like legs with fins, so they have to use mechanical stilts to walk on land. In the book their heads and faces are described as pale with no hair. From this description some visual elements become obvious choices even before doing any concept sketches—amphibians, fish, and reptiles were my first references. *(continued on next page)*

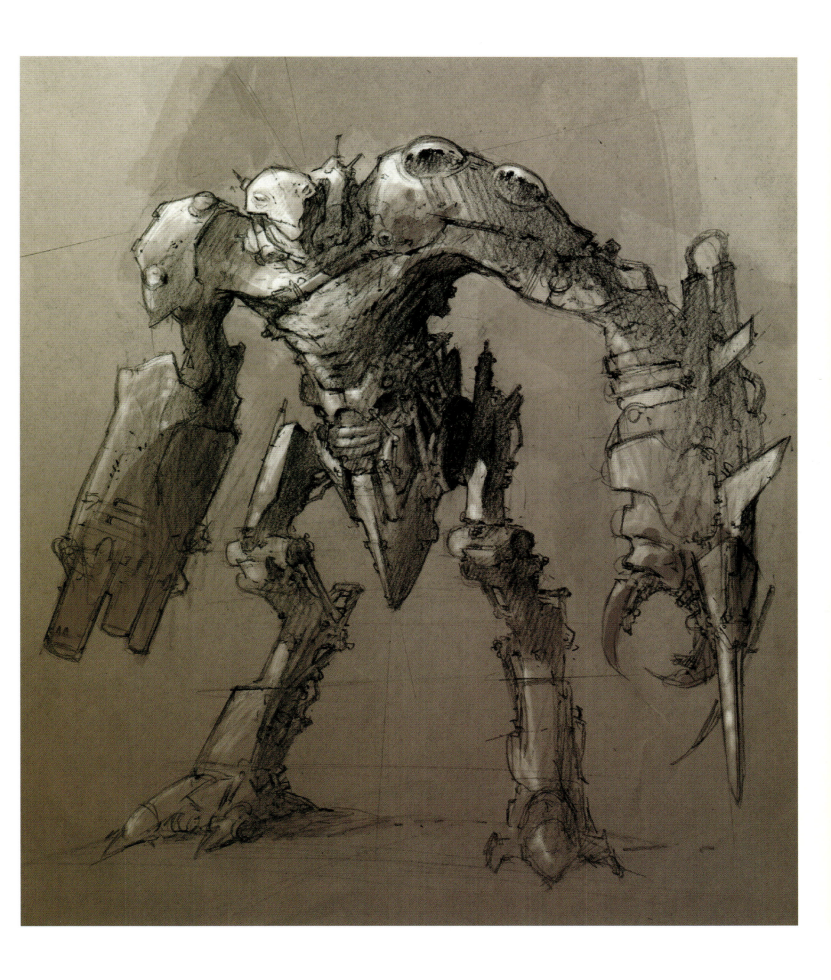

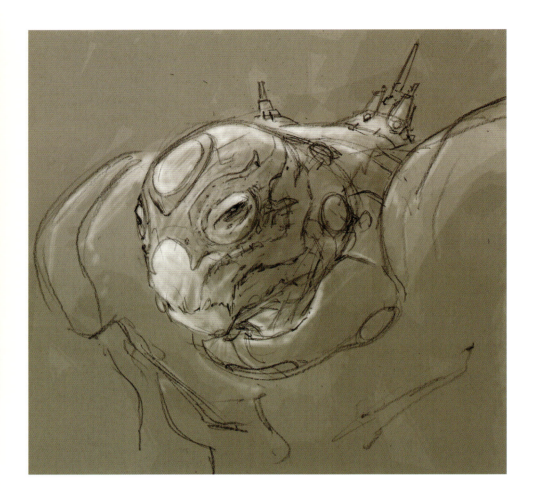

# NEEWALKER

**feature-film alien concepts** | The Softwire

After several sketch explorations, the Neewalker is cleaned, refined, and ready for final coloring. The color treatment and textures were very important, since they reinforce certain concepts. Rust stains, for example, are associated with corrosion and can resemble blisters or patches of disease. A pale bluish color for the skin also reinforces the unhealthy characteristics of the creature.

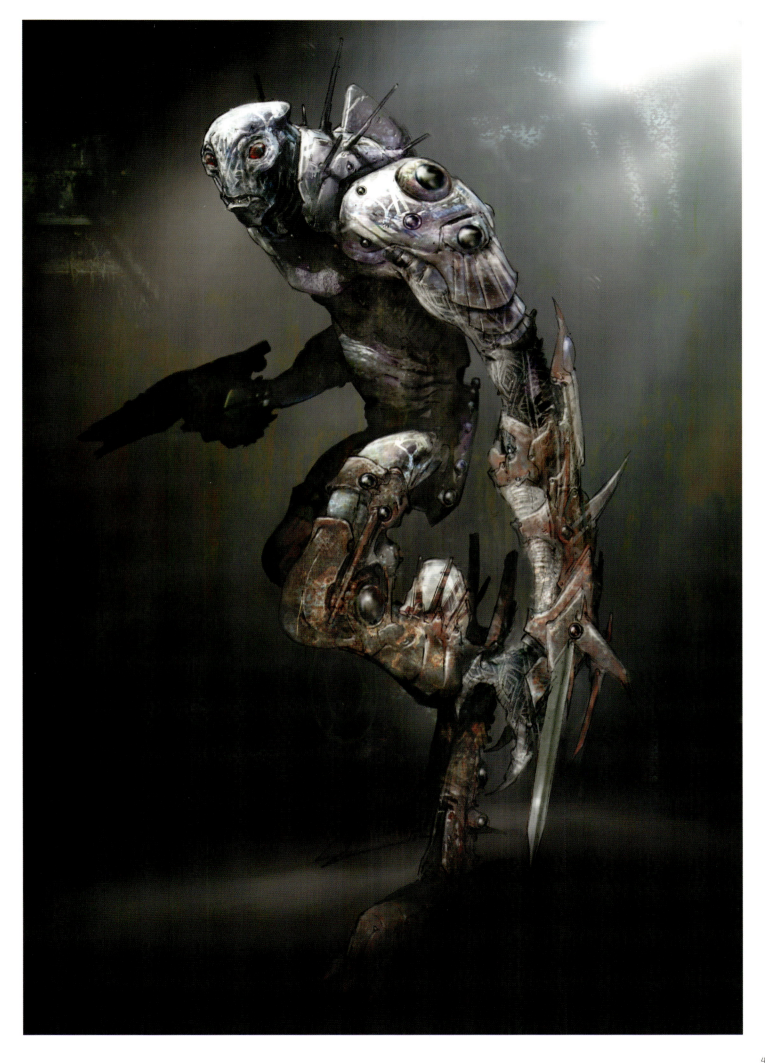

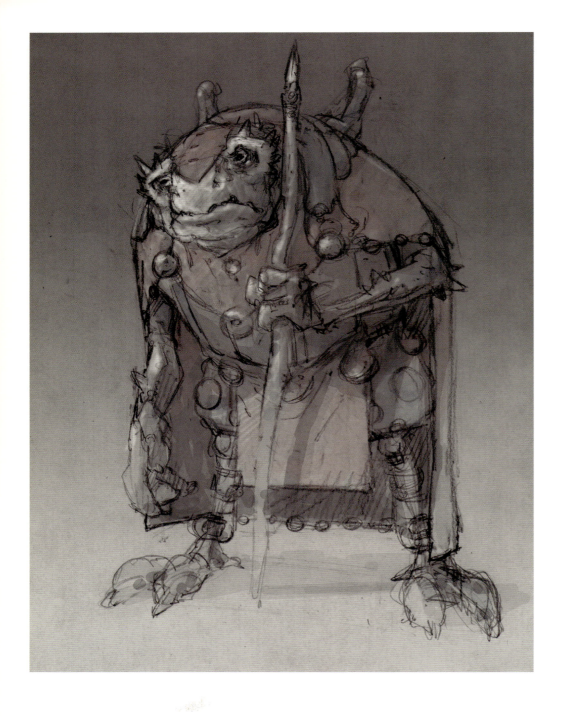

# WEEGIN

**feature-film alien concepts** | The Softwire

Weegin is a crusty creature with red, bloodshot eyes and thorns. They have remnants of wings; only the ragged stubs of bones remain. He suffers from a Napoleon Complex and is always upset. I wanted him to look like something between a bird and a reptile, with small eyes and old, wrinkled, and cracked skin. I added a lot of detail on his face to convey his personality.

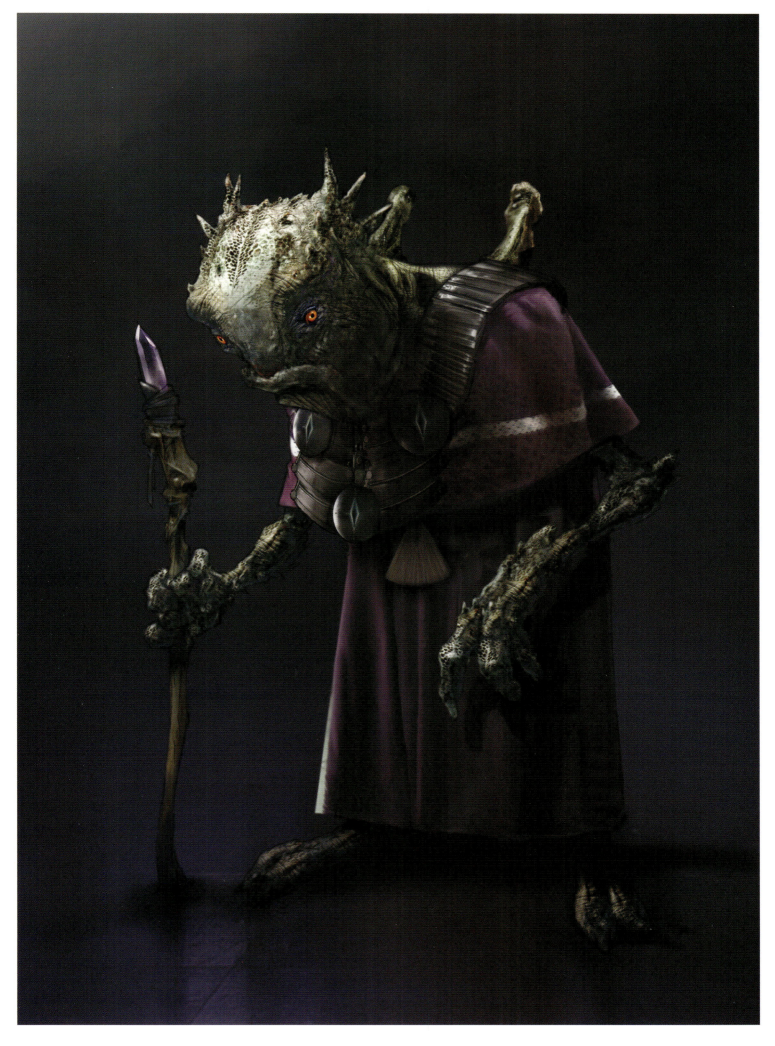

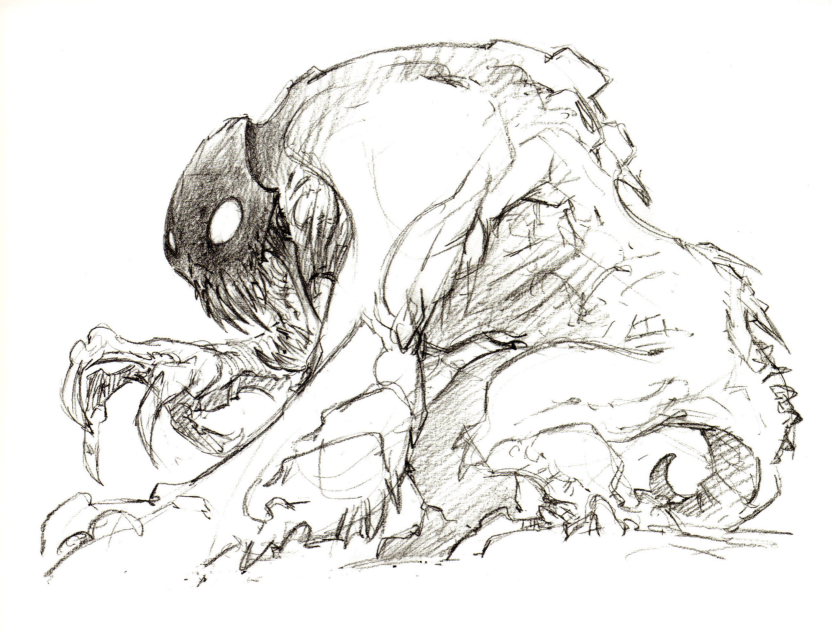

# MERCEDES BEAST

**concept for the Mercedes Benz TV commercial**

Turn-around is usually fast for commercials. A fast pace is always challenging; it forces me to extract the essence of the creature or character very quickly. It also requires a certain understanding of shapes, features, and details and the emotional response they trigger, subconscious or not. In my opinion, the commercial turned out very nicely.

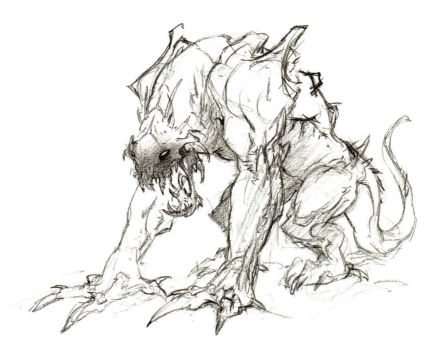

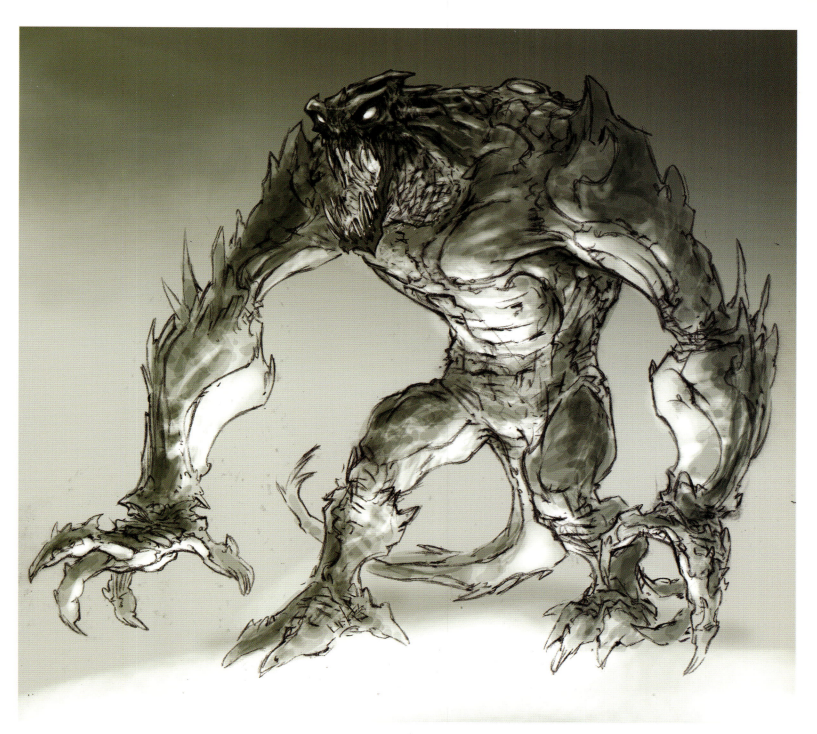

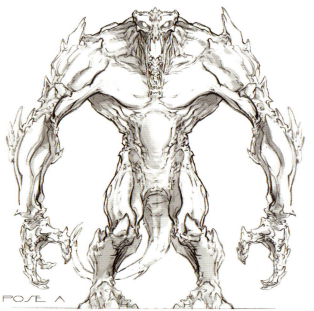

POSE A

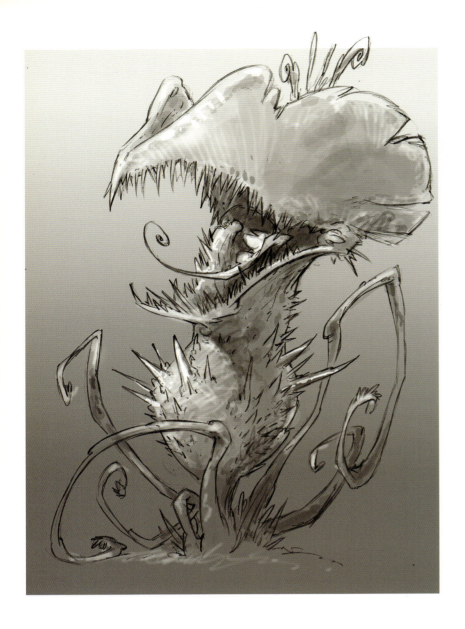

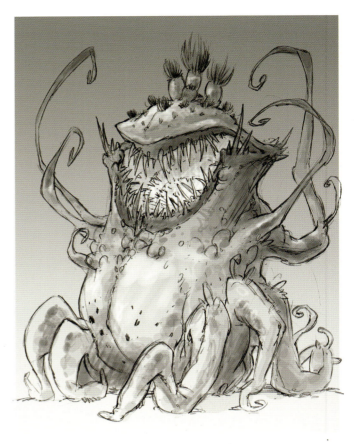

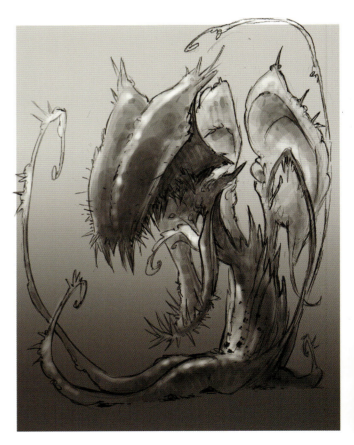

# CARNIVOROUS PLANTS

concept for TV commercial

These plants are another good example of extracting the essence of the creature very quickly. The idea was to create a mean, semi-realistic, and yet cartoony-looking plant. I spent a few hours researching the Internet for references of exotic and carnivorous plants, such as the Venus Fly Trap. The next step was to explore variations from these references. I made sure that certain features such as tentacles or thorns were always present, helping convey a certain amount of fear or revulsion. *(continued on next page)*

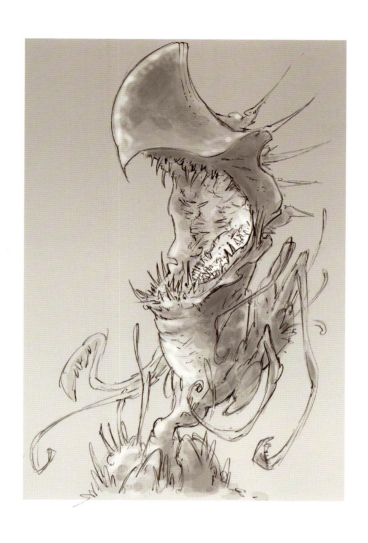
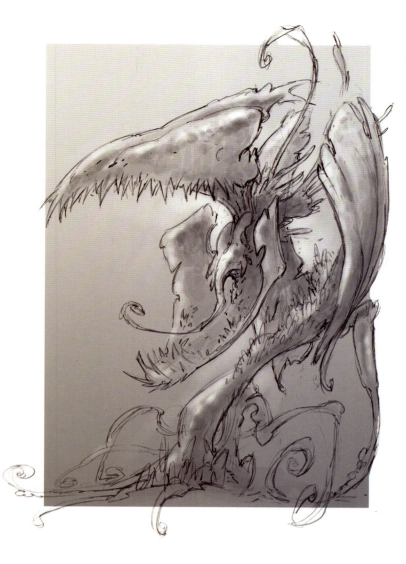
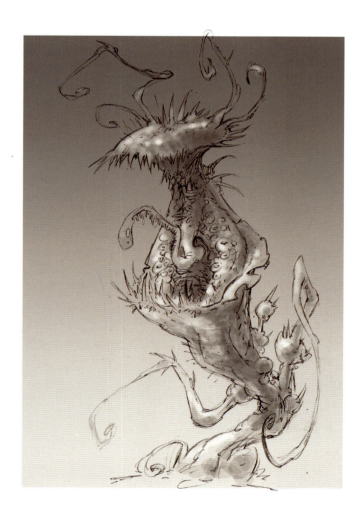
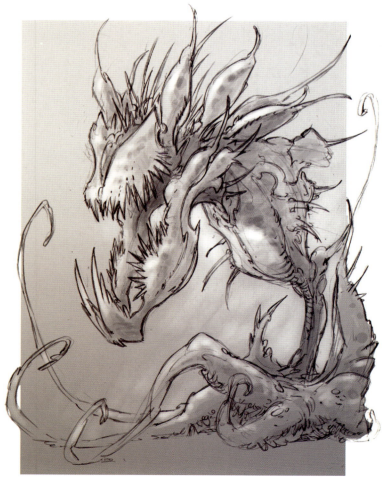

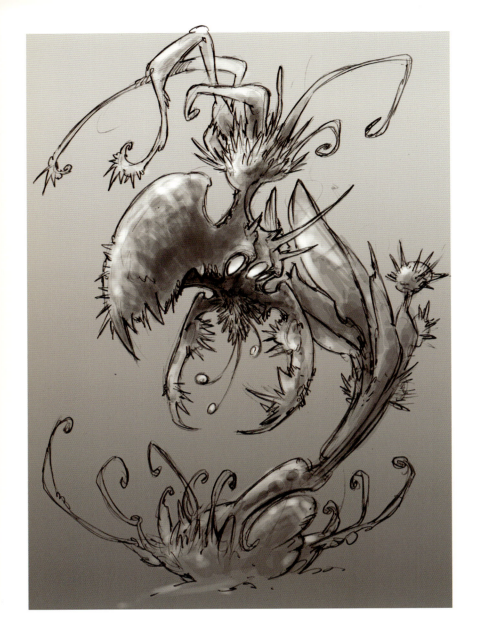

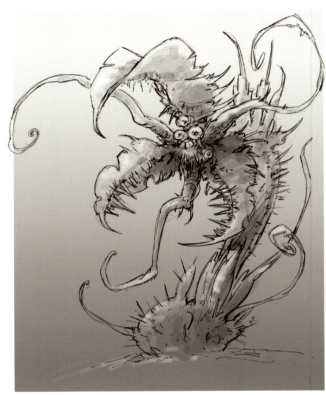

# CARNIVOROUS PLANTS

**concept for TV commercial**

Here are some more variations on the plant. To me, the snake-like idea feels less interesting, but I wanted to try it regardless, because sometimes it inspires new designs.

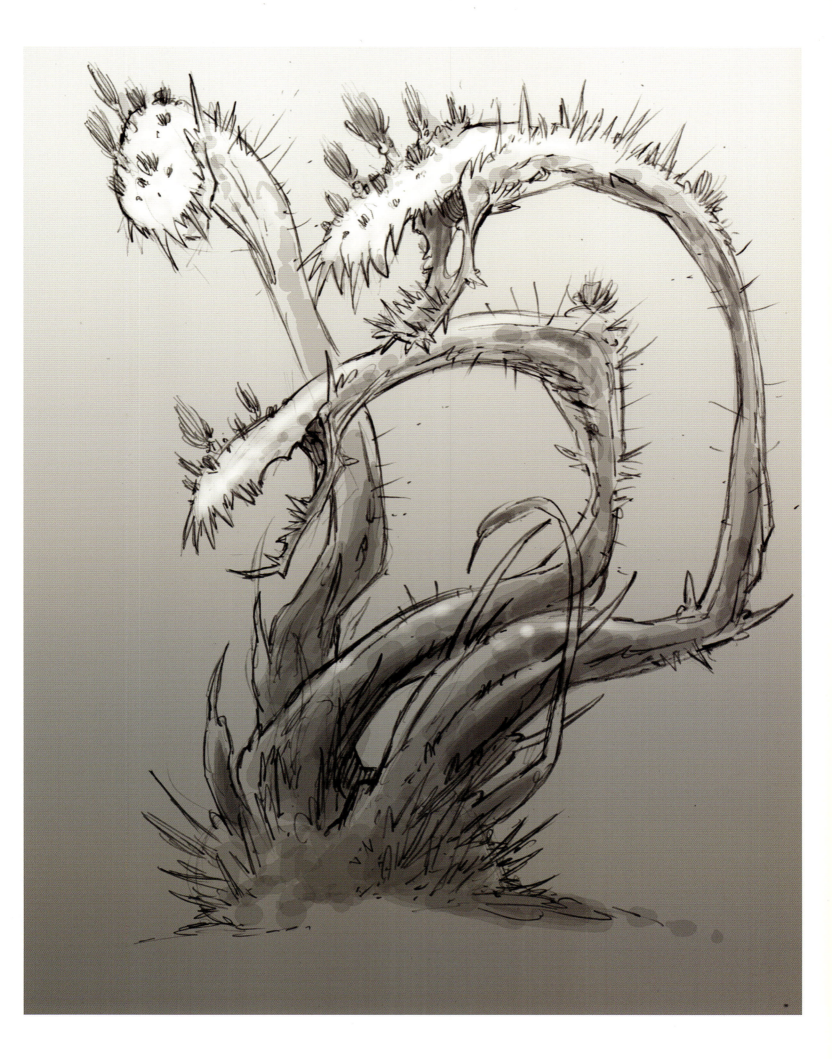

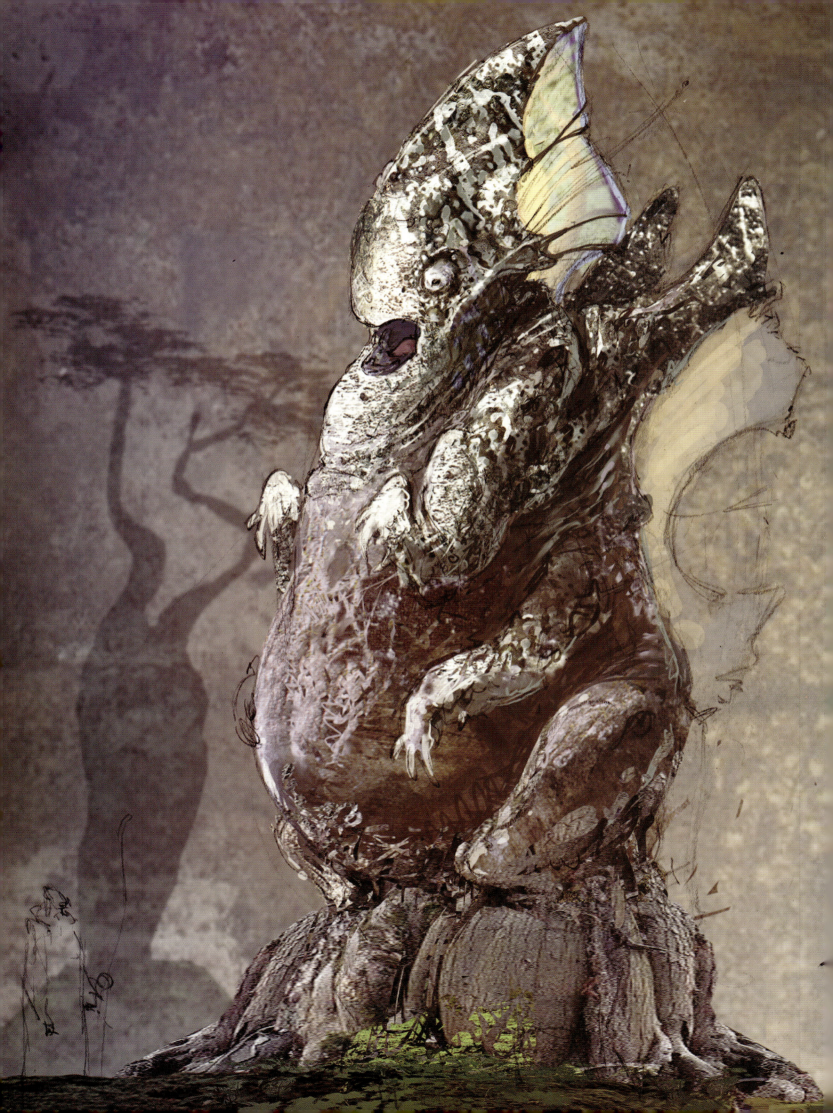

## chapter three | games

"Art is much less important than life, but what a poor life without it."

—Robert Motherwell

VENT CREATURE
**creature concept** | Myst 5

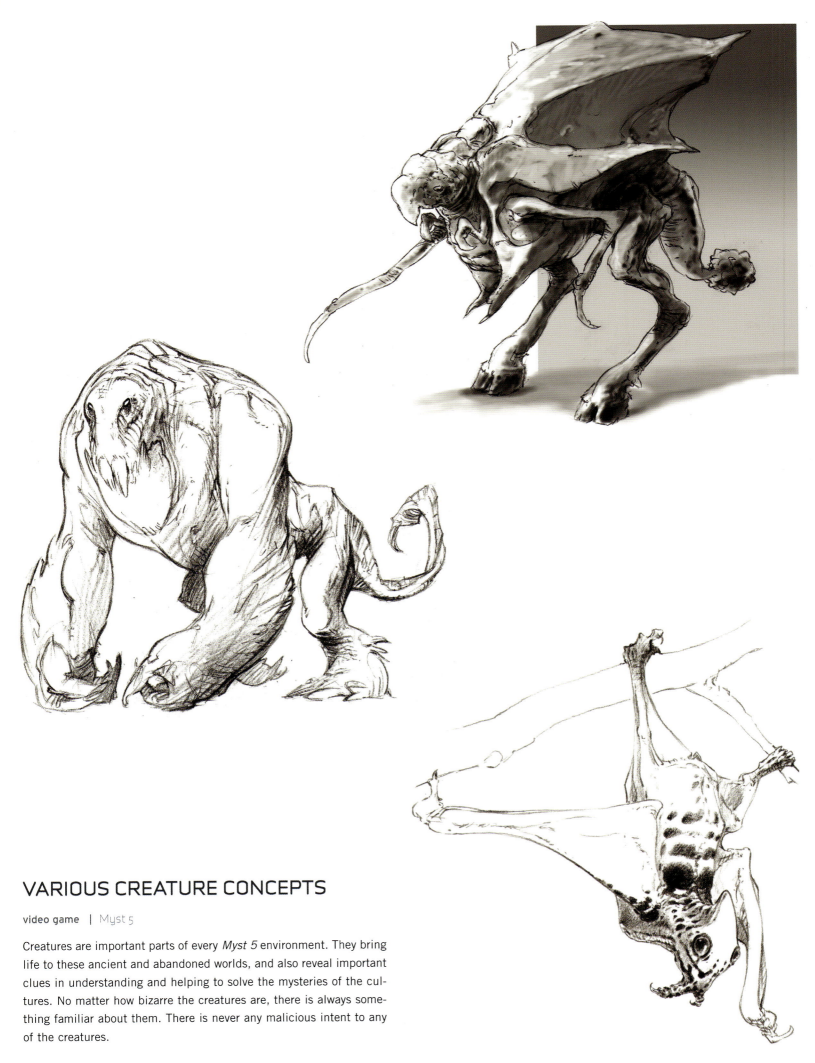

# VARIOUS CREATURE CONCEPTS

**video game** | *Myst 5*

Creatures are important parts of every *Myst 5* environment. They bring life to these ancient and abandoned worlds, and also reveal important clues in understanding and helping to solve the mysteries of the cultures. No matter how bizarre the creatures are, there is always something familiar about them. There is never any malicious intent to any of the creatures.

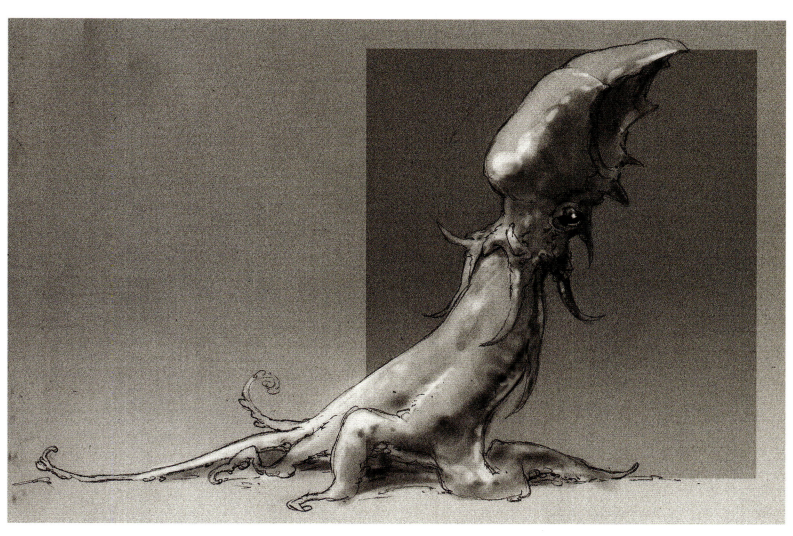

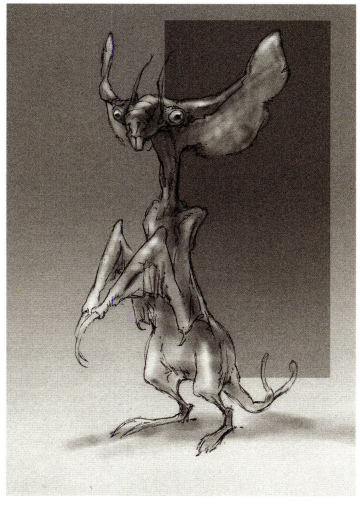

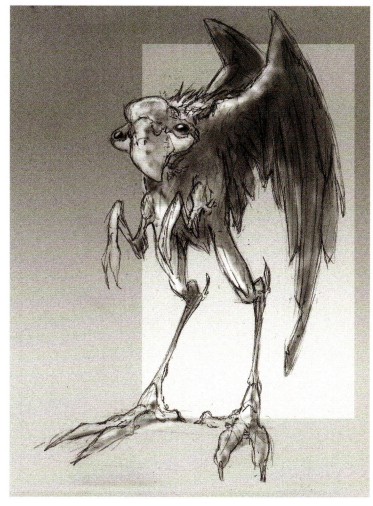

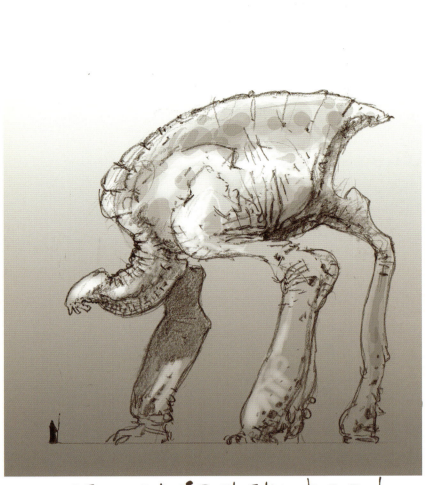

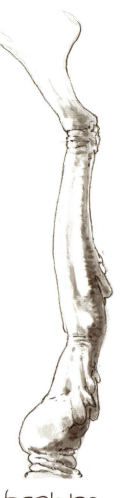

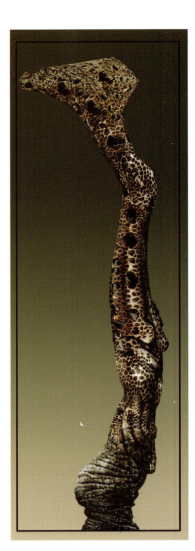

asymetrical slug head
creature

back leg

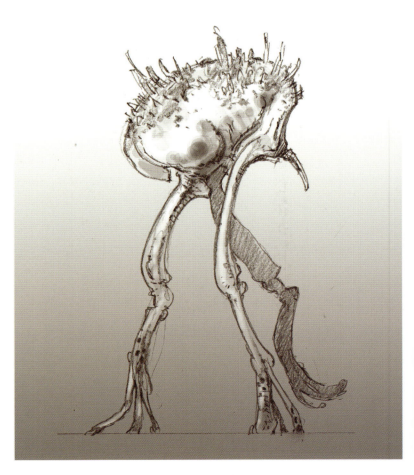

## VARIOUS CREATURE CONCEPTS

**video game** | Myst 5

It was important that all animal or plant life in these different worlds convey a sense of mystery, fascination, puzzlement or even amusement, but never horror or fear. That "something familiar" in all of the creatures is important also because the player can make some visual associations and expect the creature to react and behave a certain way. The fun part is when the creature goes against that expectation and completely surprises the player. What is tricky is to create a believable anatomy that works both ways.

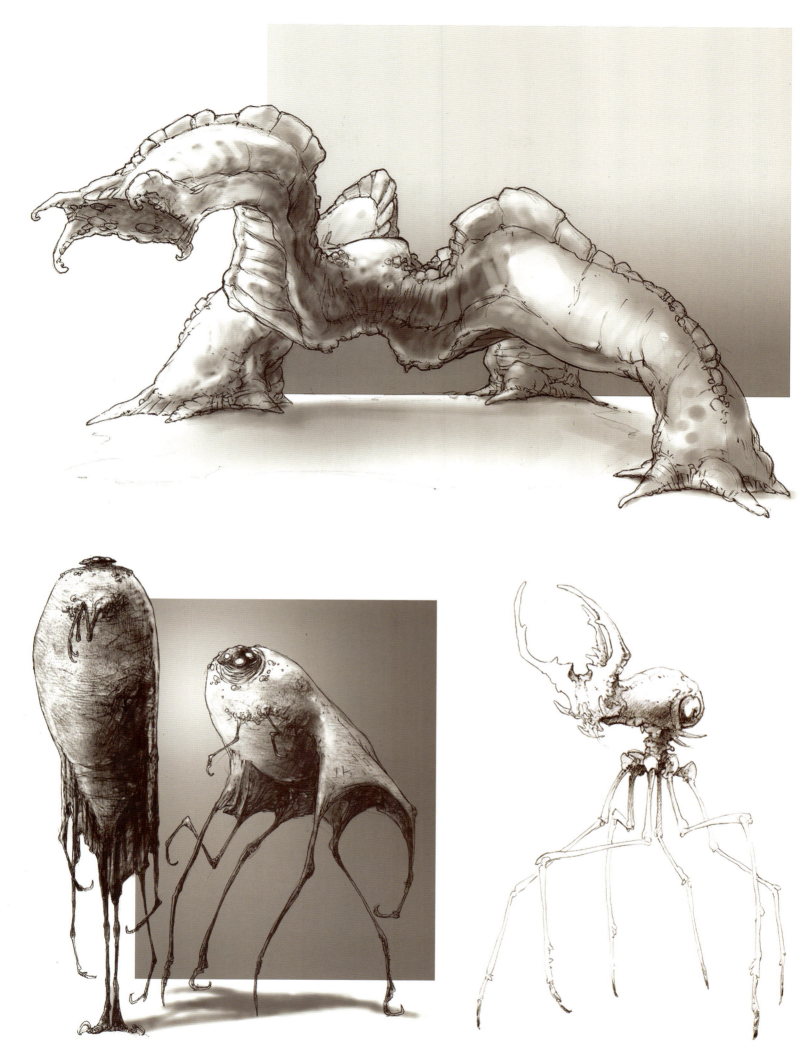

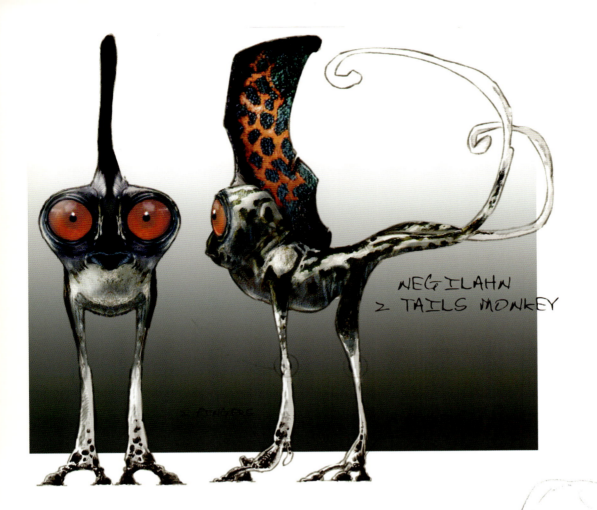

NEGILAHN
2 TAILS MONKEY

# VARIOUS CREATURE CONCEPTS

**video game** | Myst 5

Here are more creatures, some amusing and some majestic. I always like to play with different style treatments when drawing sketches. Sometimes I will feel like doing it in pencil and other times in black inks. I really have no preference; I like to switch mediums regularly, believing that if you don't use it, you lose it. Coming from a European training has helped me a lot in practicing numerous styles.

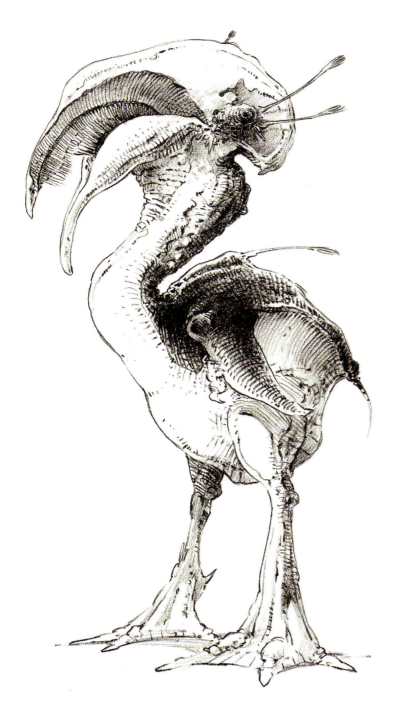

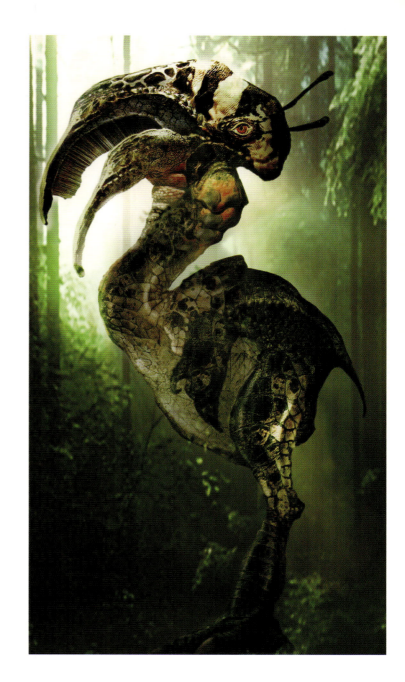

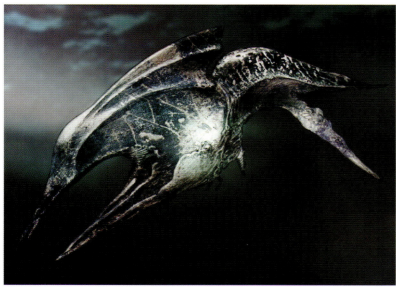

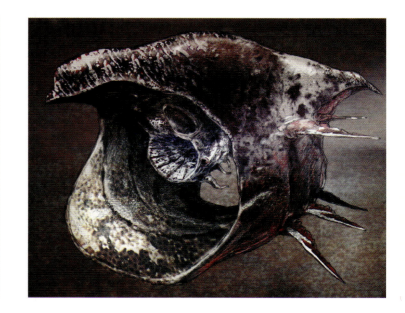

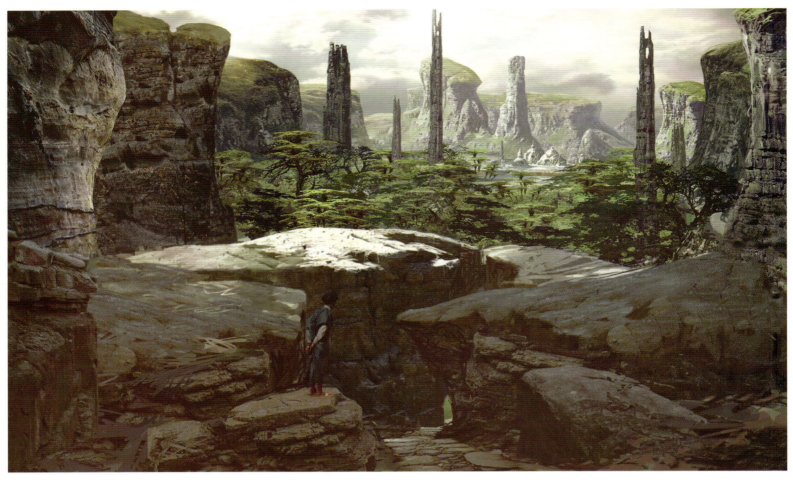

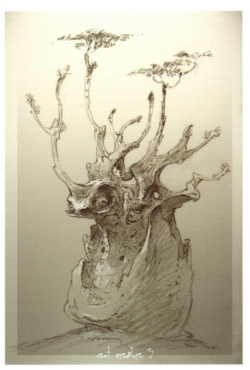

# TAGHIRA FOREST & CREATURE TRANSFORMATION

**video game** | Myst 5

Vent-trees are everywhere on Taghira. They expel the excess heat from the planet's core and serve as a mechanism to trigger mating. Specific heat signatures will attract different creatures. Once a creature finds its designated vent, it sits on it like a bird on its nest. The heat will slowly fuse the creature with the vent and grow into a tree-like exten-sion. At maturity, the tree will bear sterile spores that become fertile by floating away from the tree to merge with other spores. Once merged, the spores will grow into new creatures. This was a compli-cated concept to convey visually.

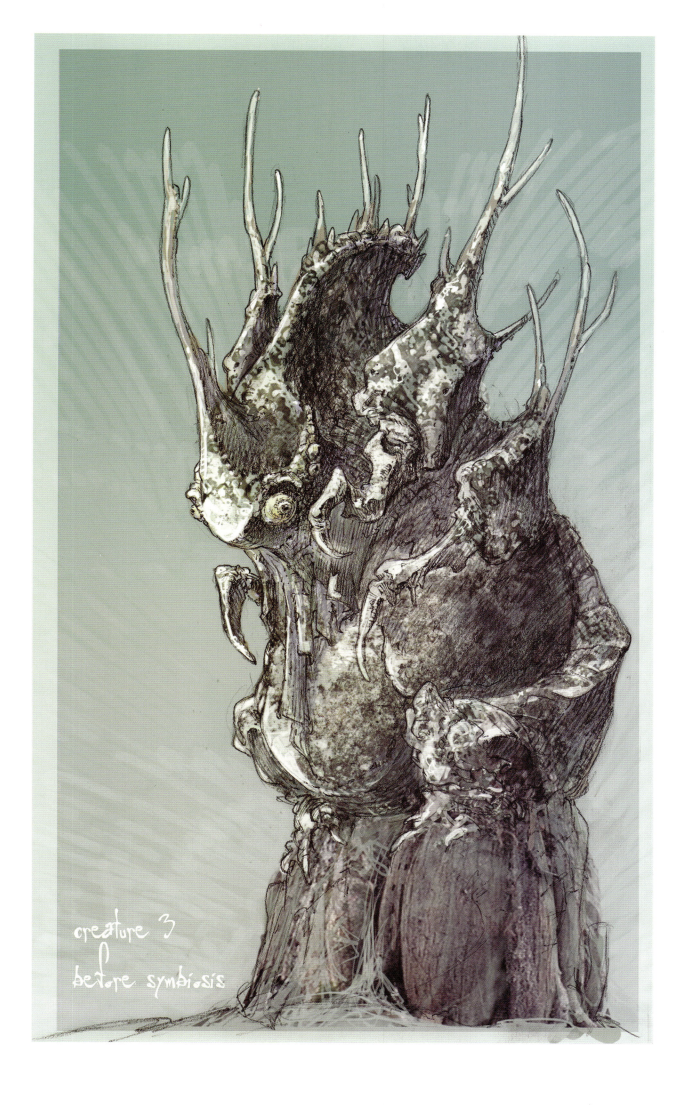

creature 3
before symbiosis

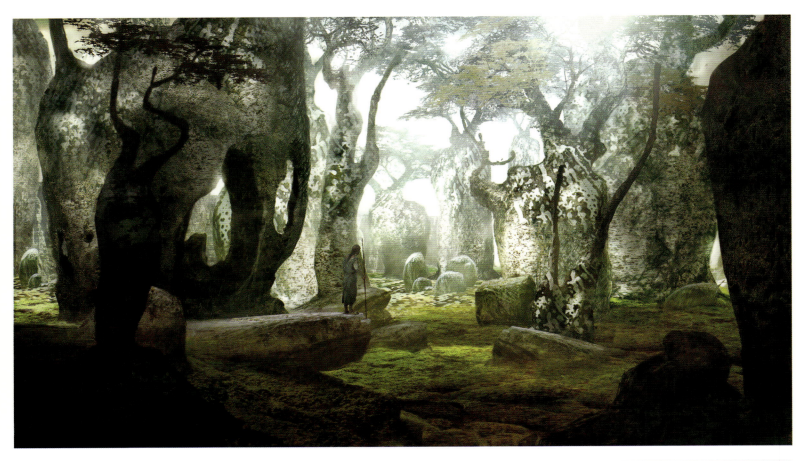

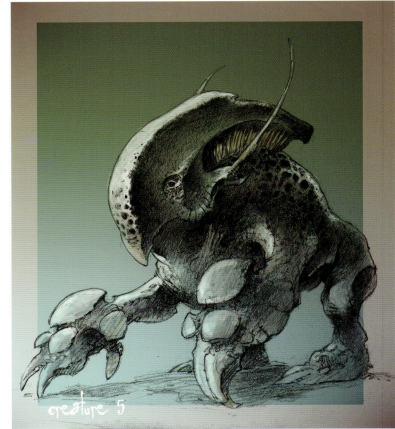

creature 5

# TAGHIRA FOREST & CREATURES

**video game** | Myst 5

In Taghira there is a mutual symbiosis between the creatures and the vent-trees. It is the essence of life in this world. To visually convey that idea, I decided to explore a look that would combine the vent-tree elements and textures with the surrounding animal life. Each creature would have a specific contribution to the life-cycle of the planet, yet each creature would still carry some visual properties and features that differentiate them from the vent-trees.

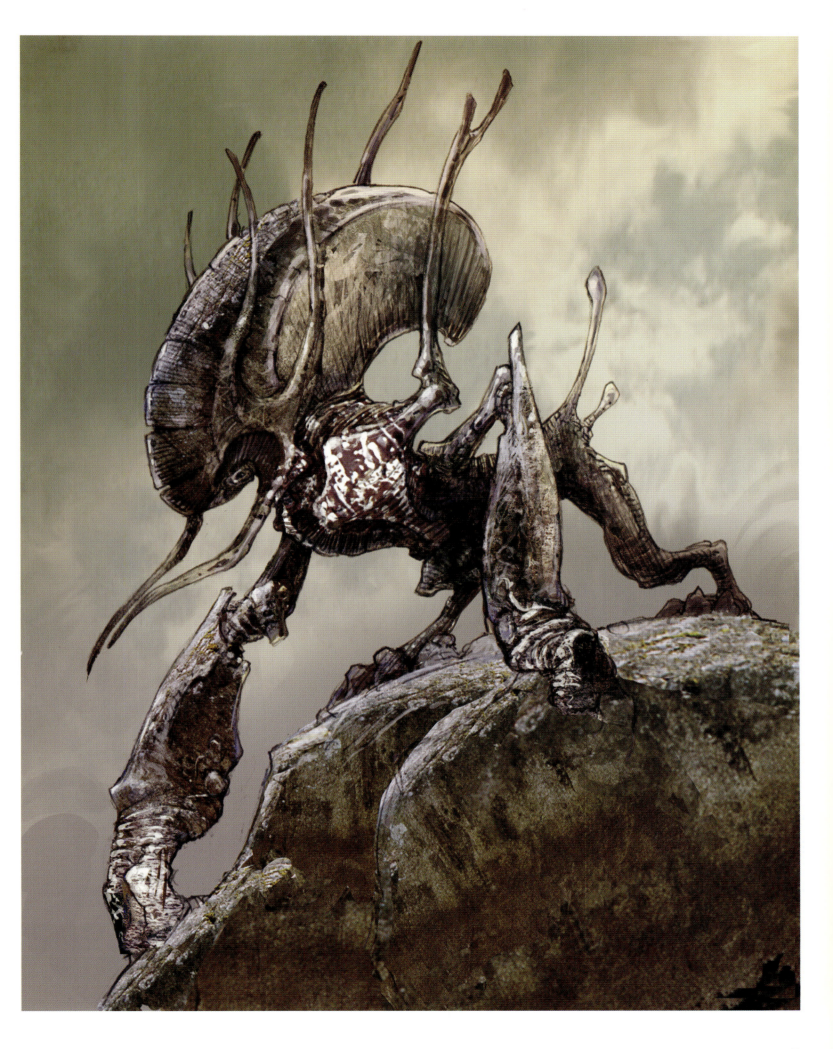

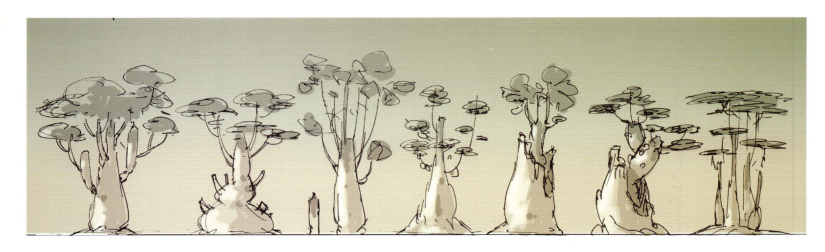

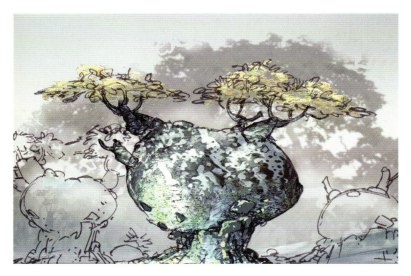

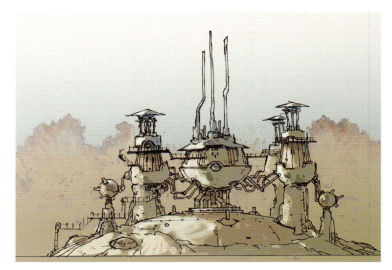

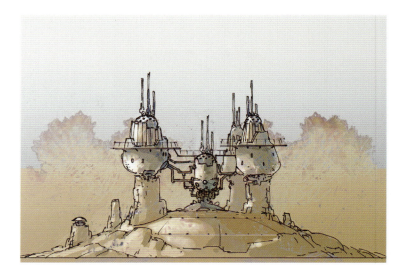

## TAGHIRA TREES & VILLAGES

**video game** | *Myst 5*

One thing I greatly enjoyed while creating environments and creatures is thinking everything through. Taghira, for example, is all about symbiosis, aesthetic, and how everything works together. It is important in *Myst 5* because it helps solve a mystery. These concepts have to work together at many levels: shape, color, scale, scene composition, and even element or character behaviors. Each will help the player understand the relationship of all parts of Taghira. The village, for example, is a great visual clue to understanding the environment. Its design and functioning mimics very closely the symbiosis between the creatures and the vent-trees.

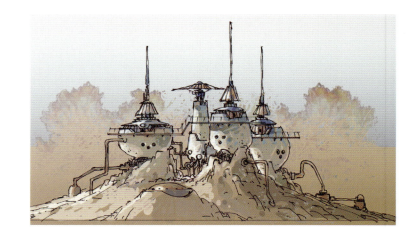

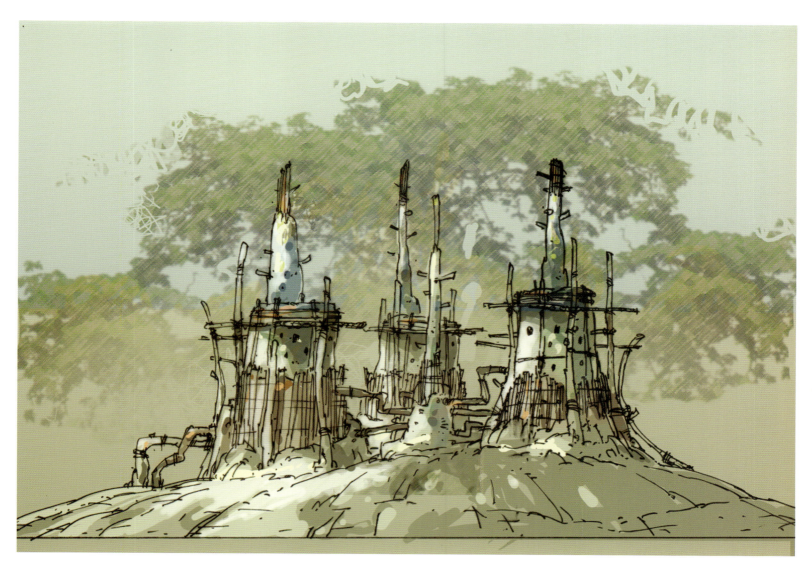

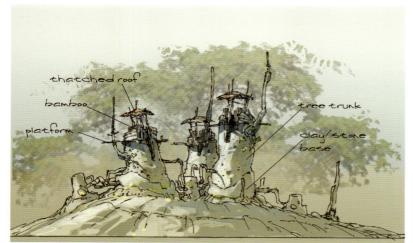

thatched roof

bamboo

platform

tree trunk

clay/stone base

bark

platform

bamboo

clay/stone base

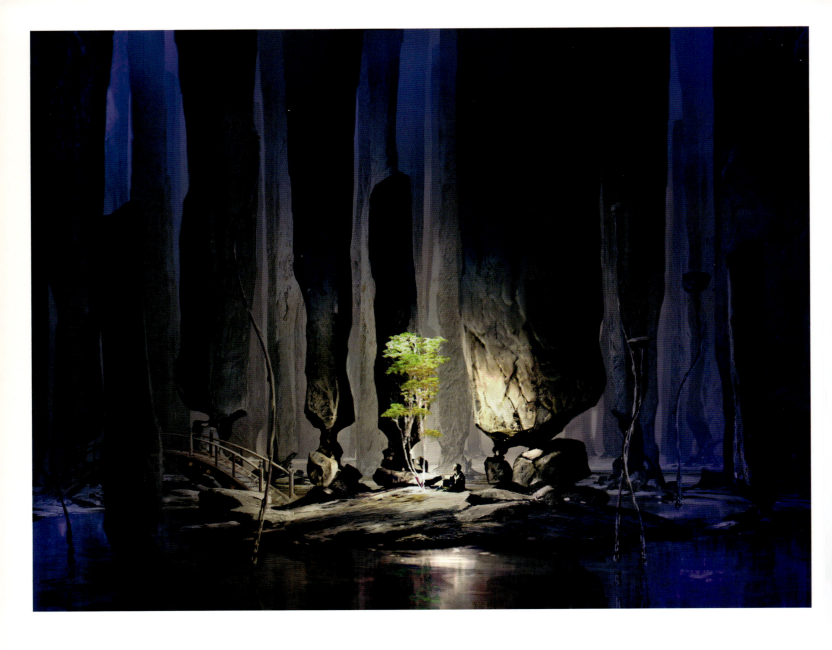

## DIREBO (above)

**video game** | Myst 5

Direbo is a resting place, a quiet and mysterious garden. Giant stone monoliths stand erect and still like ancient guardians. A small tree at the center of the garden summons the player deeper into the environment. Having vertical, repeating monoliths in every direction reinforces the sense of calm, as well as the use of dark, blue colors.

## THE GREAT CAVE | UNDER THE ICE (opposite)

**video game** | Myst 5

The Great Cave is where the great D'ni city was originally discovered. It is deep underground, and many miles long. The cave is always in the dark, except for one great moment, when all its beauty and enormous scale is revealed. I wanted to keep the colors very monochromatic, and played a lot with rich reds and oranges to help show its massive size.

That underwater place is to be seen only through the window of a submerged observatory pod. The player does not interfere with the environment; he would only be an observer, gathering information on the underwater life.

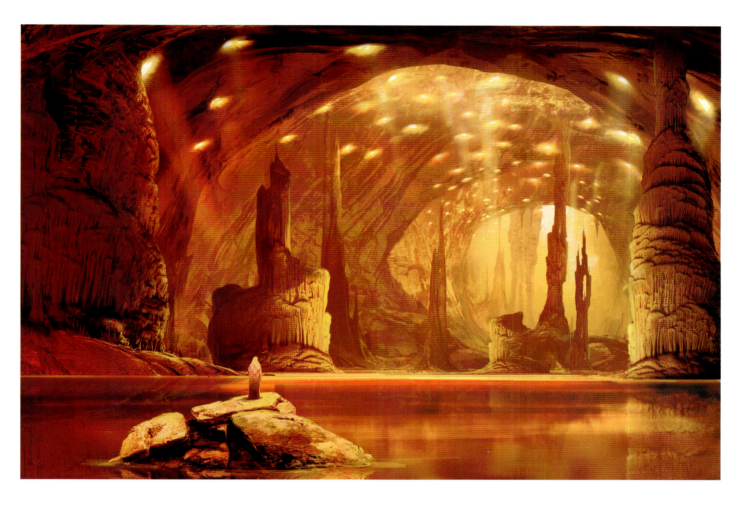

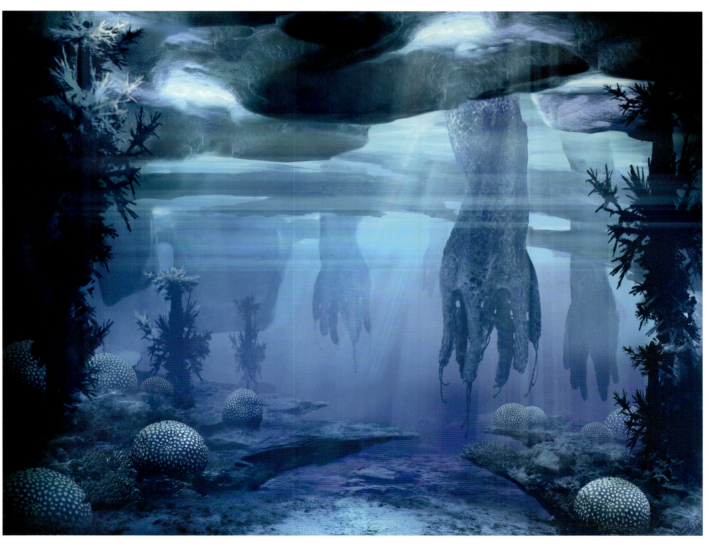

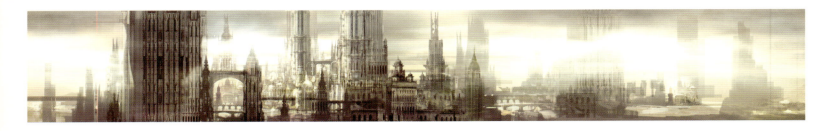

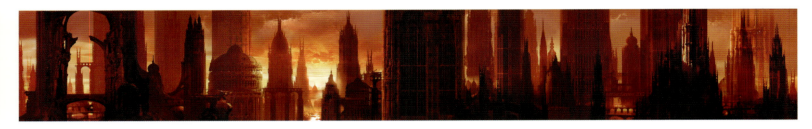

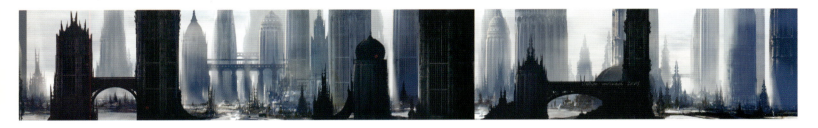

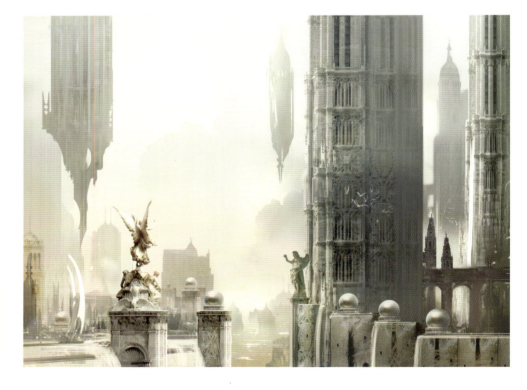

# RAVNICA: Box Art | Plains *(above)*

**trading card game** | Magic: The Gathering

This was my first *Magic* assignment. I had a lot of fun doing these three boxes. Unfortunately, after the text and the center character piece was added to the layout of the box, very little of the city remained.

Doing the Ravnica series was a new experience for me. Because the cards are very small and the artwork even smaller, the challenge was to create paintings that convey each idea quickly with strong moods and without going overboard with the details.

# RAVNICA: Island | Forest *(opposite)*

**trading card game** | Magic: The Gathering

One effective way to create a painting quickly is by reusing the same elements as much as possible. It could be a whole structure like the dome building, or smaller elements. All is well as long as it all integrates flawlessly in color, composition and light.

Another effective way to paint quickly is to keep the perspective simple and use cylindrical structures as much as possible, as opposed to objects that are square or rectangular. The mood and light are also key ingredients that draw eyes to the painting.

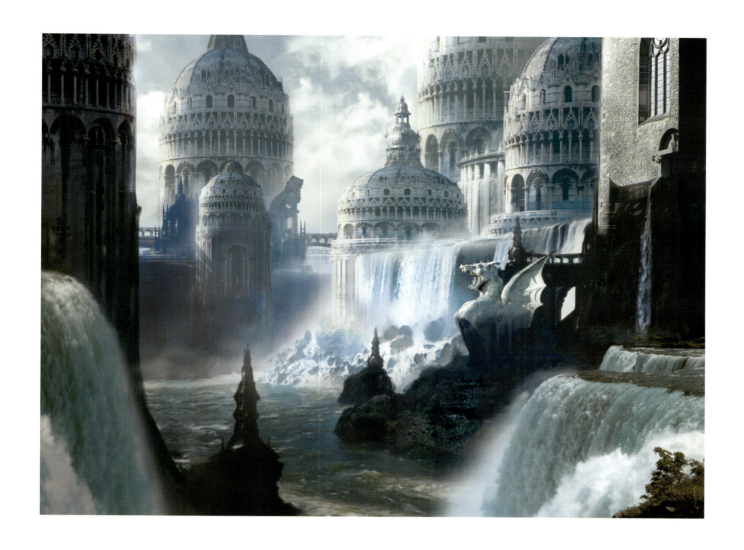

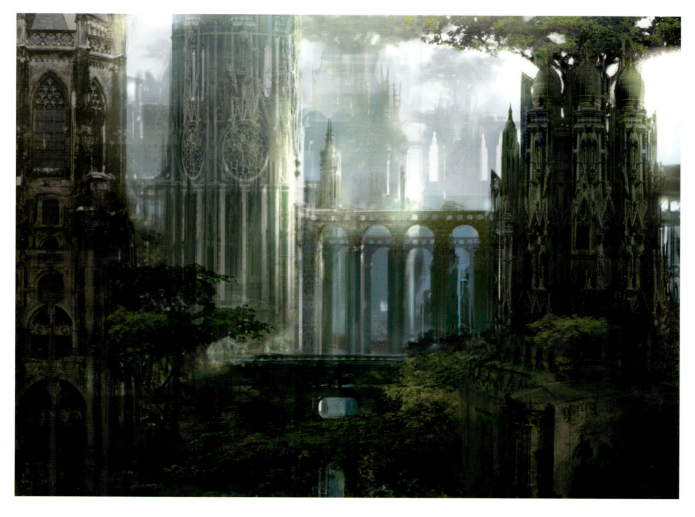

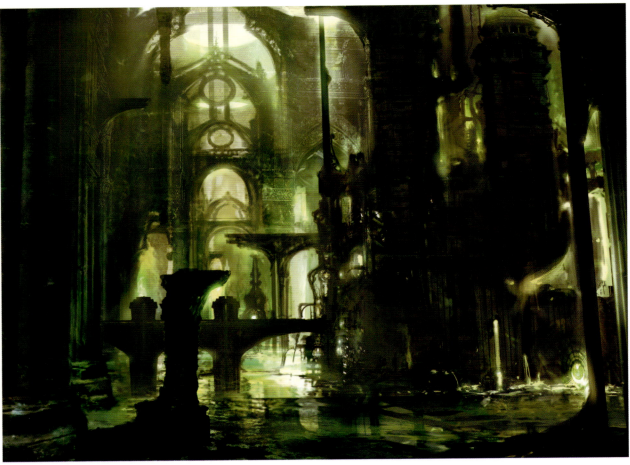

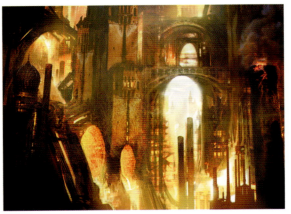
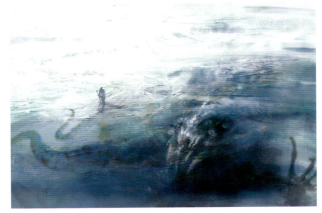

## COLDSNAP *(above)*

**trading card game** | Magic: The Gathering

*(top: Swamp)* A fair amount of dark area helped to create this painting quickly, but it also works very well for the mood of this particular piece.

*(left: Mountain)* This was the first card I did. A few experiments had to take place before I found an effective method by using simple perspective, reuse of elements, a strong mood and lighting.

*(right: Dark Depth)* This was my first monster for *Coldsnap*. This one was tricky: it had to be menacing and frightening, yet had to be under the ice, its features barely seen. It had to be treated almost as a silhouette, with tentacles and thorns as its only distinctive features. They read quickly without details and they convey revulsion and danger. Add a few pale eyes and the indication of a mouth filled with fangs and the desired fear is achieved.

## RAVNICA *(opposite)*

**trading card game** | Magic: The Gathering

*(top: Marit Lage)* This was done after Dark Depth. The creature is out of the ice! The creature is said to be so frightening that it is almost impossible to describe: something similar to the Cthulhu creature from a H.P. Lovecraft novel. Once again, it's all about a menacing silhouette. I wanted to place the creature in a fog, with tentacles and thorns that are even more prominent. Glowing eyes and teeth help suggest some additional frightening features. I placed the man on the left to show how large the creature truly is.

*(bottom: Phyrexian Iron Foot)* The Phyrexian Iron Foot is a creature made out of flesh and metal held together by magic. I hadn't done zombie-like creatures since I worked on the animated series *Ghostbusters*. I wanted these three monster cards to have a very painterly feel. It allowed me to stray a bit from Photoshop to explore Painter more.

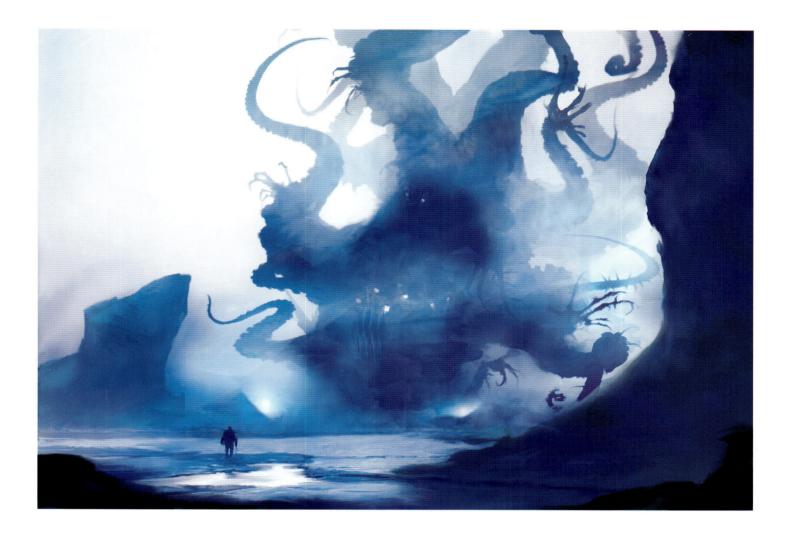

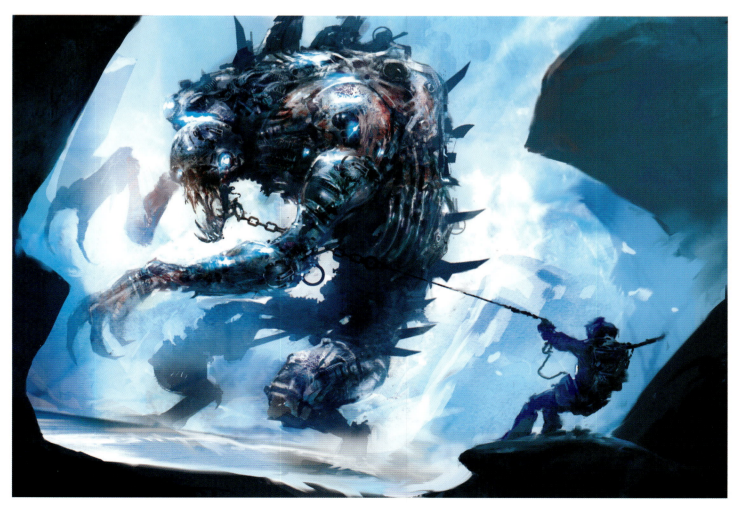

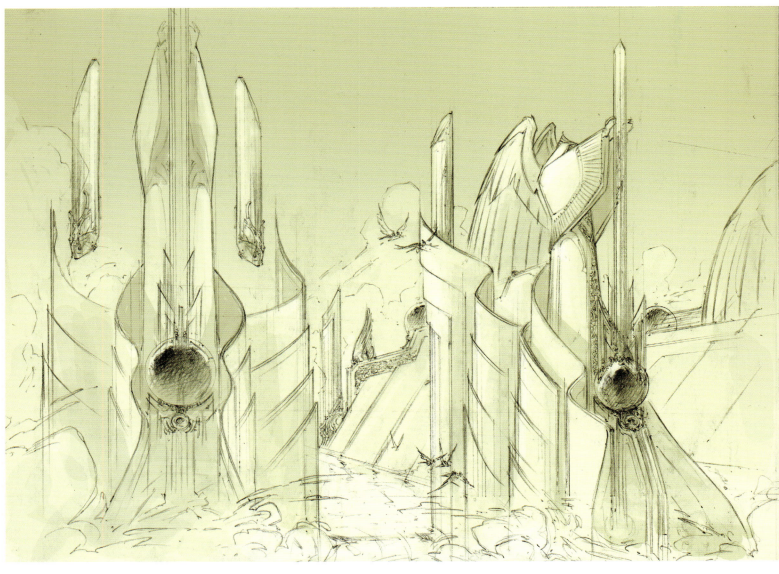

# HEAVEN

**video game** | Heaven: The Game

You don't get to conceptualize Heaven very often. I had an enormous amount of freedom regarding the overall look of the project. I looked for inspiration in some of my favorite architects and artists: Mucha, Sullivan, Mackintosh, and Otto Wagner. I am also fascinated with Neo-Classic architecture as well as the Stalinist style. This project gave me the opportunity to explore all these styles.

*(above: Angel Pillars)* These pillars stand on both sides of a misty canyon. As the player flies past them, the mist will slowly fade to reveal the entrance to Heaven.

*(right: Entrance Detail)*

*(opposite page)* This is my conceptualization of Heaven's entrance. On both sides of the entrance the walls gradually curve towards the horizon. Straight ahead, the structure reveals its massive scale as it fades into the distant clouds. I was envisioning a Heaven bathed in warm colors and made with a variety of light marbles and opals, engraved in gold, silver and other precious metals.

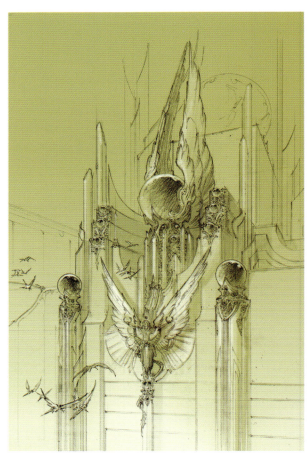

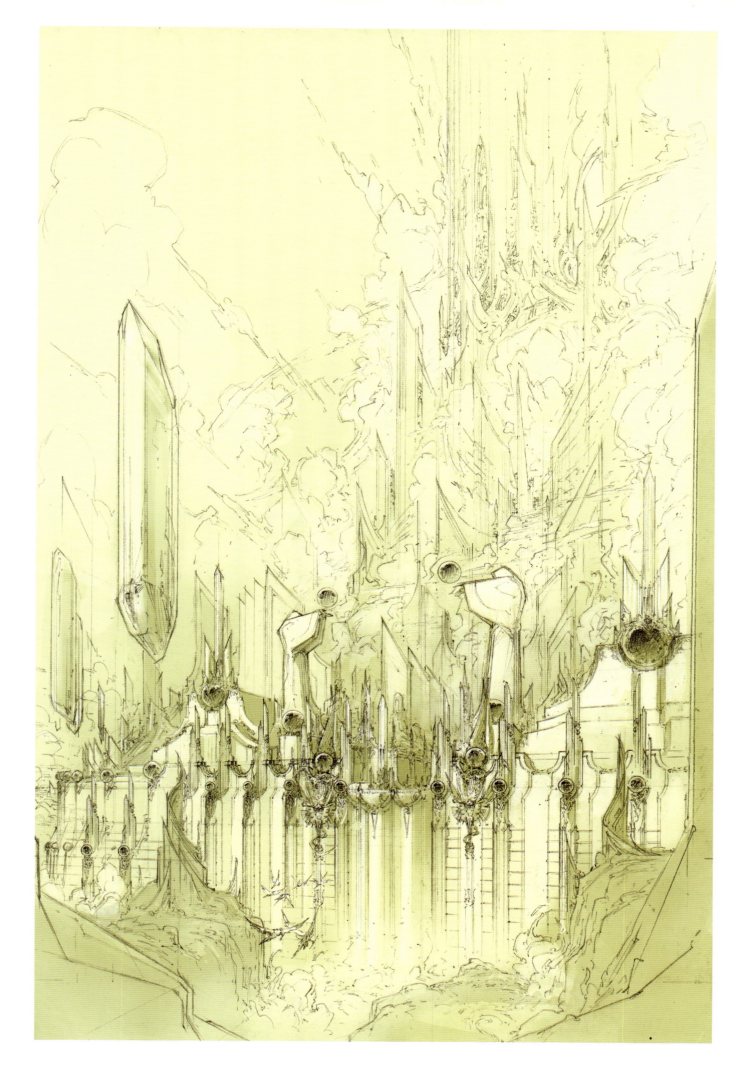

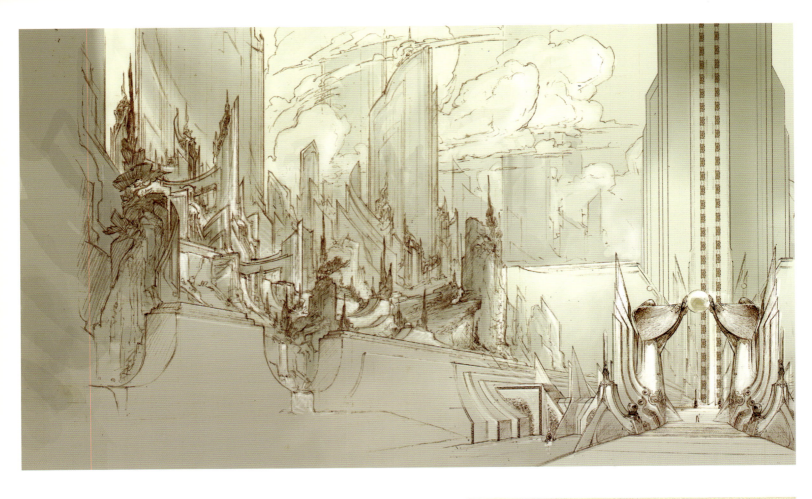

# VARIOUS ENVIRONMENTS

**video game** | Heaven: The Game

*(above: Path to the Library)*
*(right: Device Detail)*
*(opposite, top: Tunnel Gate Detail)*

*(opposite, bottom: Tunnel)* Heaven is a discovery game like *Myst*. As the player starts his journey, he will enter different areas and have to solve some puzzles in order to move forward. Much of the time, the clues to solve the puzzles will be visual and the player will have to rely on his or her recollections.

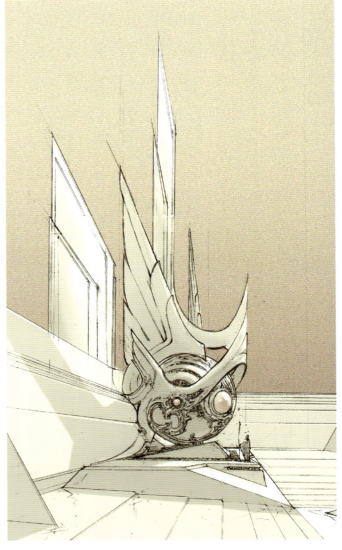

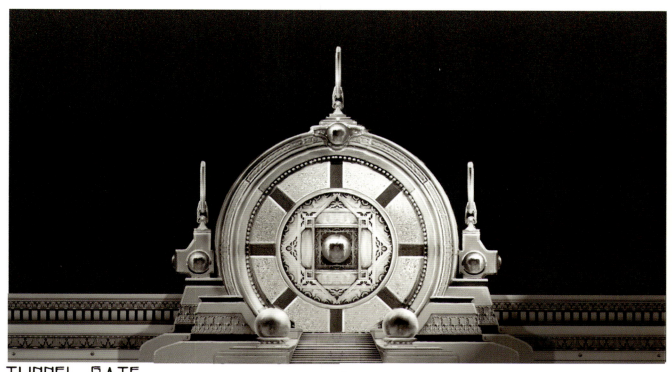

TUNNEL GATE

SIDE VIEW

TUNNEL

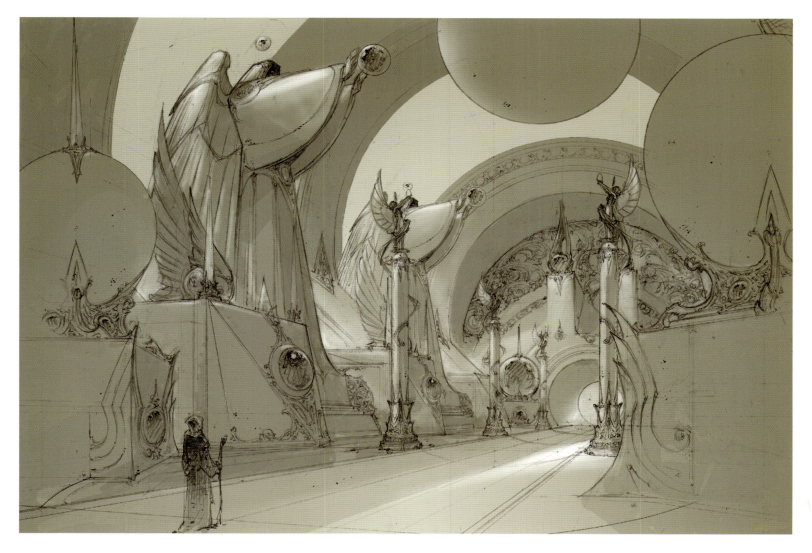

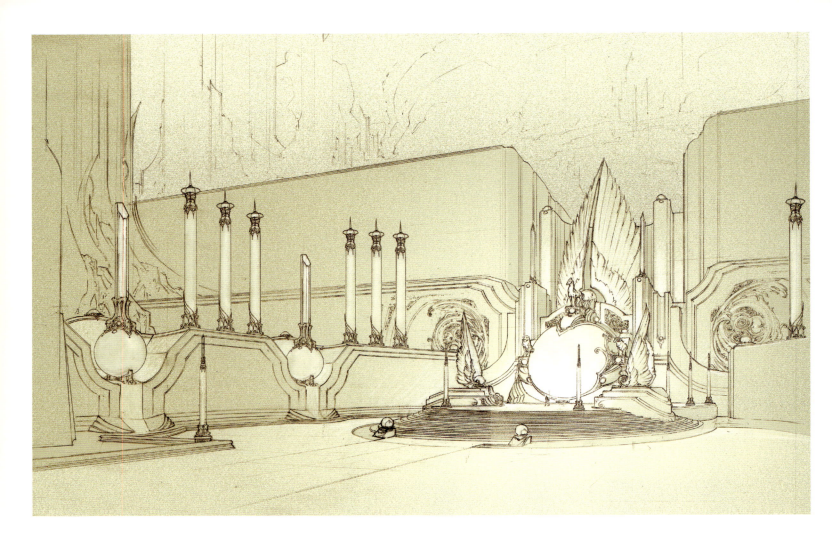

# VARIOUS ENVIRONMENTS

**video game** | Heaven: The Game

*(above: Pearl Gate Area)*
*(right: Pearl Gate Room)*

*(opposite: Pearl Gate Room Detail)* The Pearl Gate is located at the end of a wide arena. The idea behind it was to have many of the architectural elements transform and move to either create various objects, or make new openings. I didn't want it to seem in any way mechanical; rather, I wanted it to move with magic or divine effects.

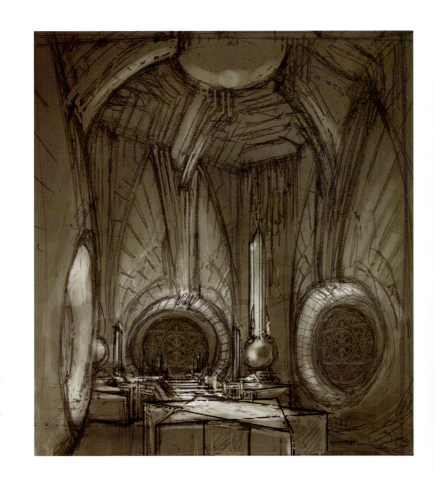

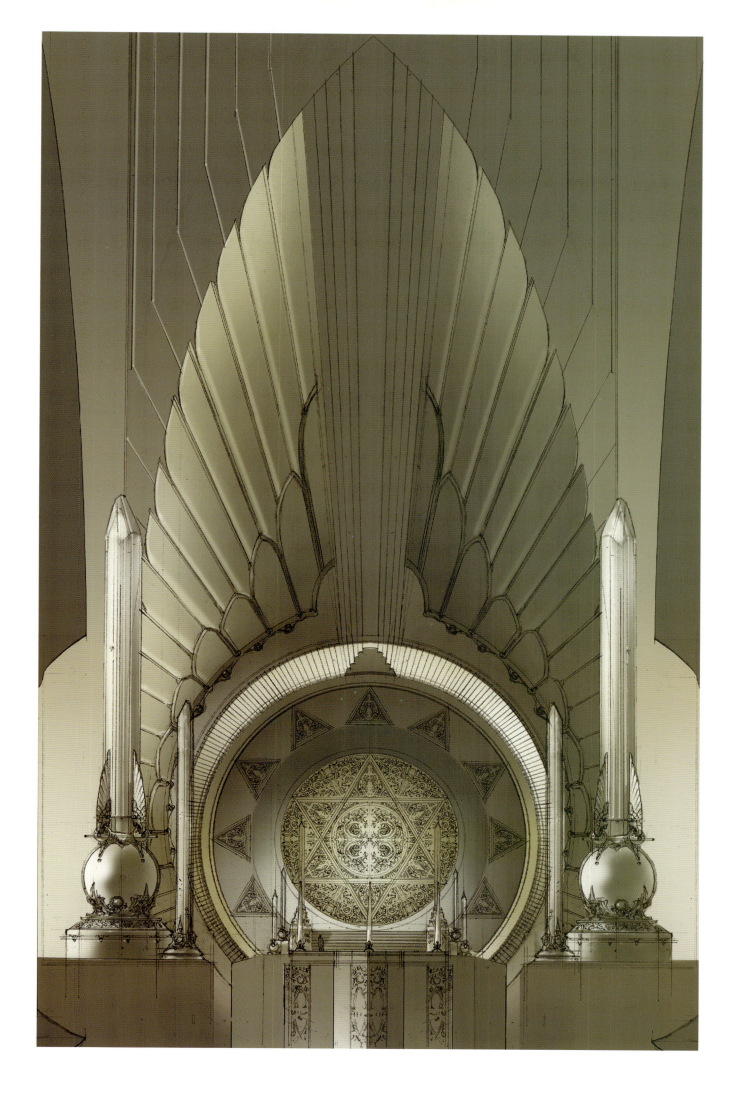

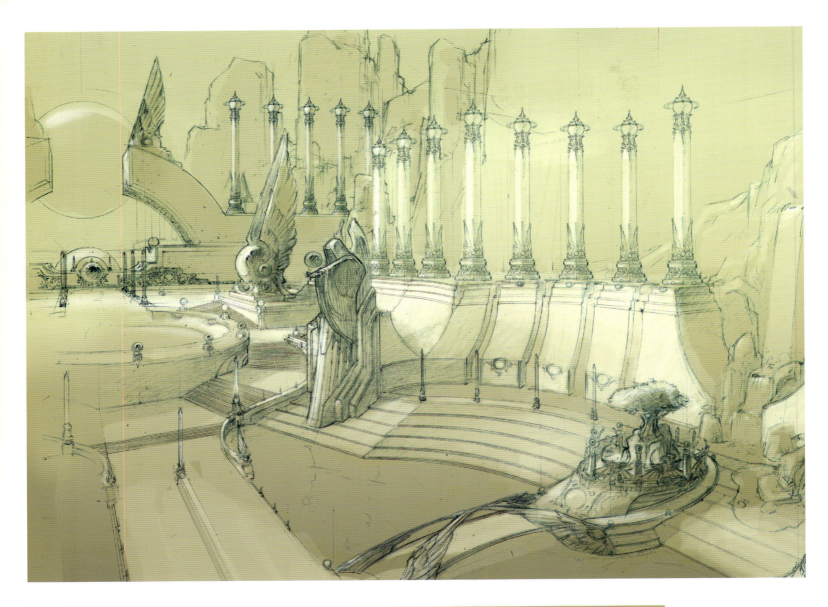

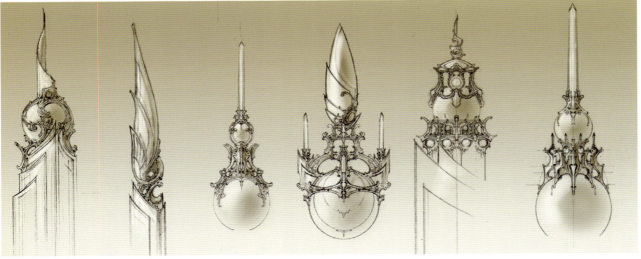

# VARIOUS ENVIRONMENTS

**video game** | Heaven: The Game

*(above, top: Tree Area)*

*(above, middle: Modular Elements)* For efficiency, I wanted to create many modular elements that could be reused. To avoid repetition, these elements would be created out of different materials. Some would be asymmetrical in shape to allow multiple views if rotated.

*(opposite, top: End of Tunnel Area)*

*(opposite, bottom: Stamp Device)*

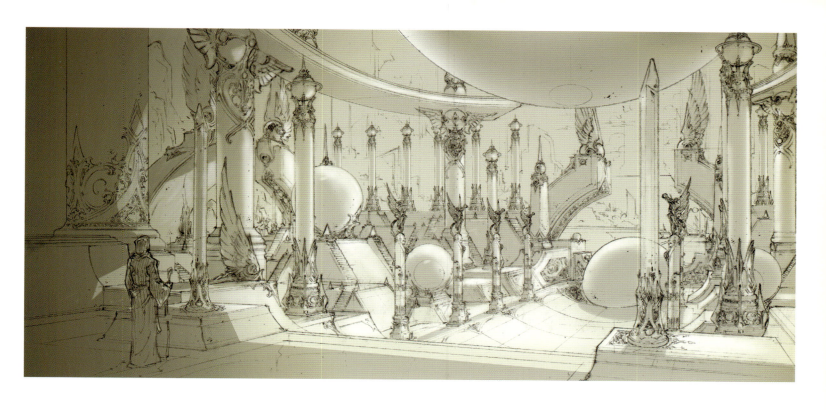

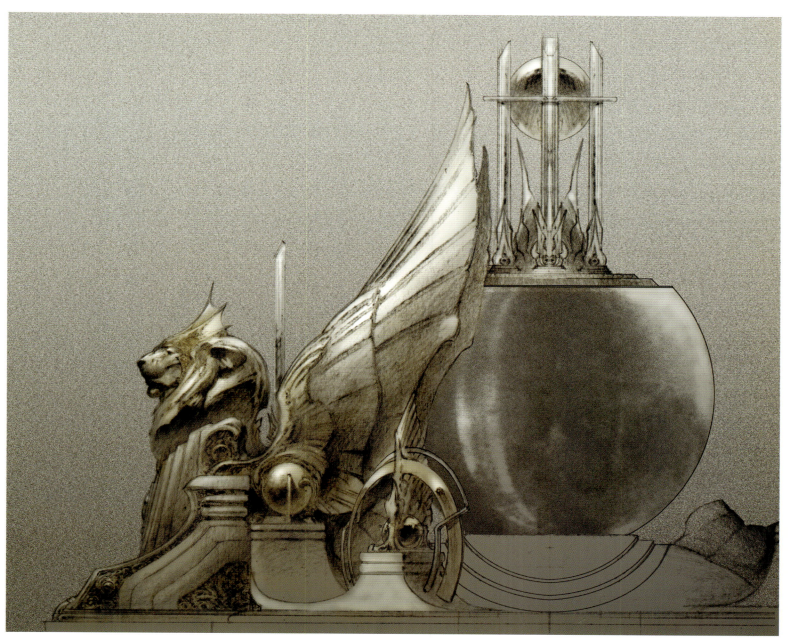

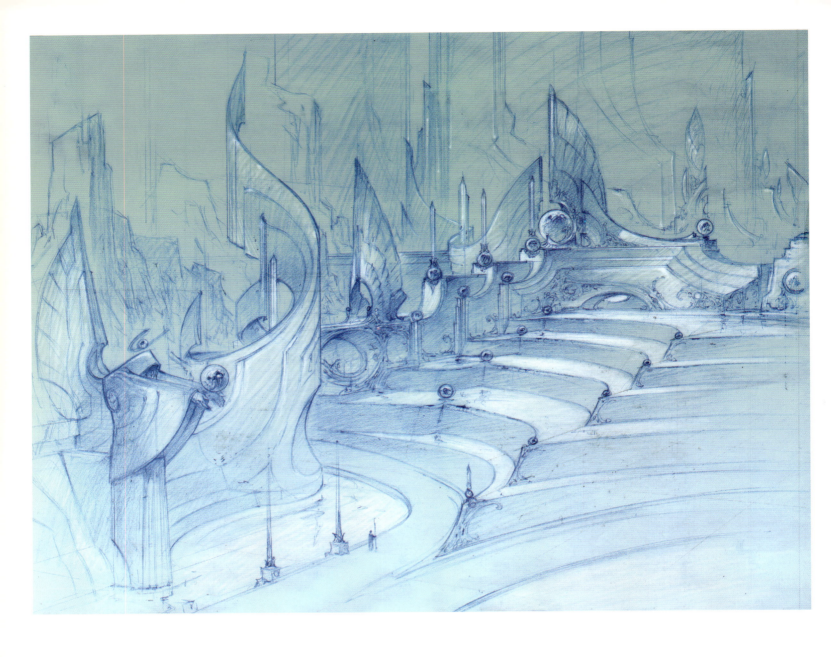

# VARIOUS ENVIRONMENTS

**video game** | Heaven: The Game

*(above: Waterfall Area)*

*(right: Eagle Being)* There are also several beings in the game. One of them that I created is described as a mix between an eagle and a lion. I found the creature described in the Bible more interesting because it had features that made it seem more frightening. However, the guidelines were for something less menacing, and more gentle.

*(opposite: Library Interior)* Most of these concepts were drawn with pencils on 11x17-inch paper or tracing paper, sometimes even larger. All these drawing were then scanned, and the color wash and highlights were then added in Photoshop.

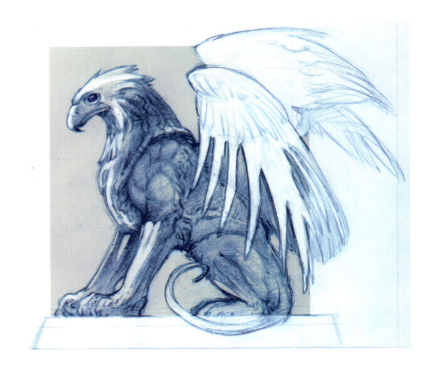

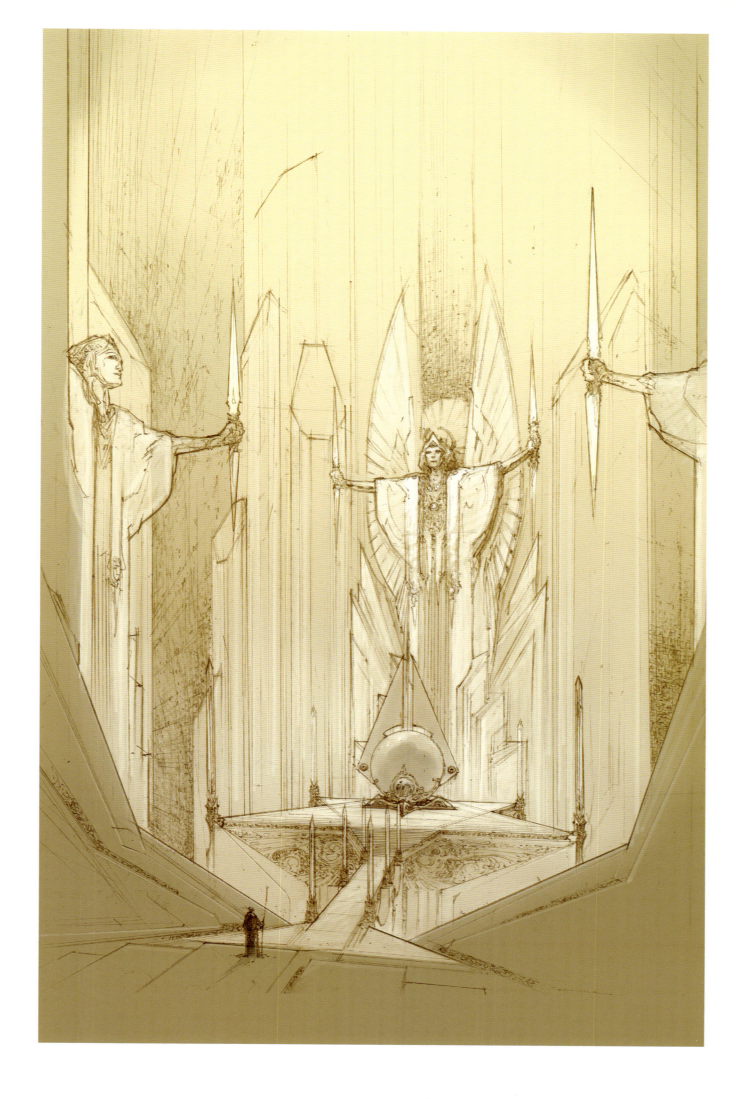

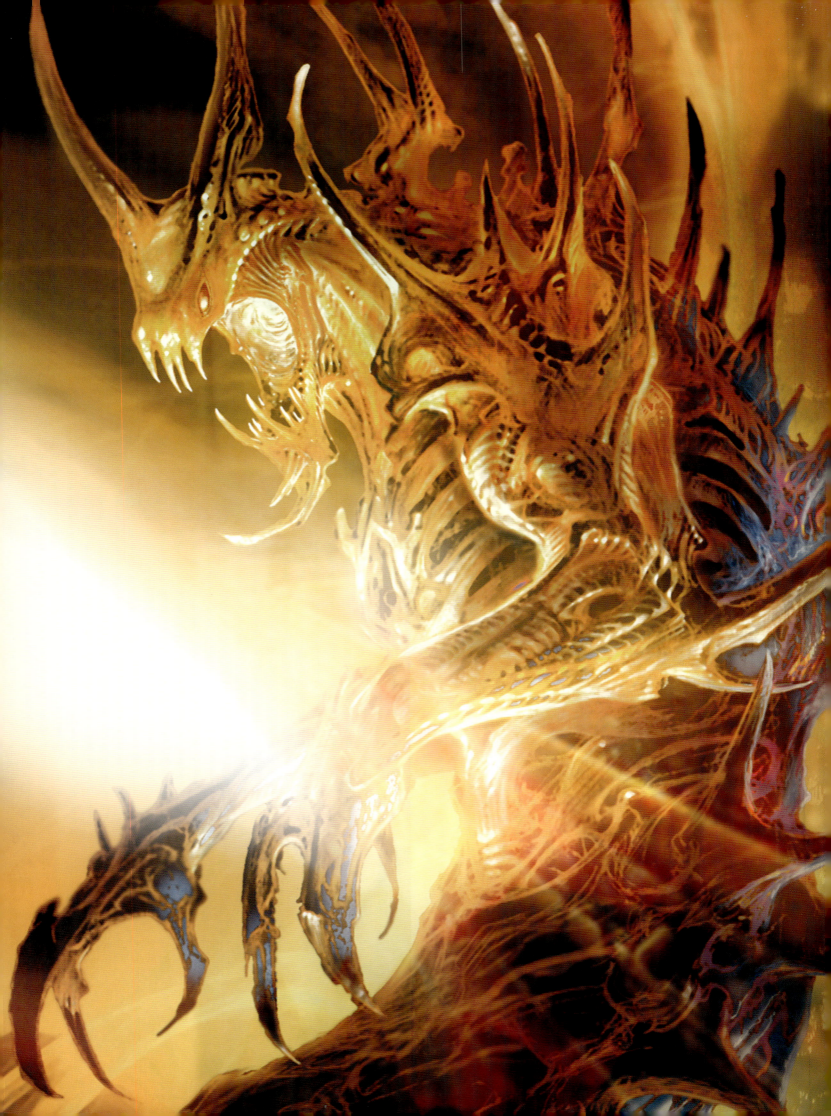

# chapter four | personal

"Life obliges me to do something, so I paint."

—Rene Magritte

FIRE DEMON
**personal project**

## ALIEN CONCEPTS

I like doing alien creatures. The process I used here is very similar to the way I designed the "Carnivorous Plants" or the "Mercedes Beast:" I extract familiar elements from various objects or animals and rearrange them to create something new, bizarre or amusing. If no familiar elements or shape can be seen in the creature, no visual association can be made. The alien then becomes too abstract and the viewer will dissociate from it.

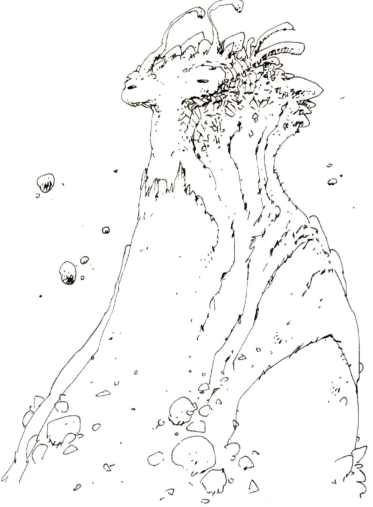

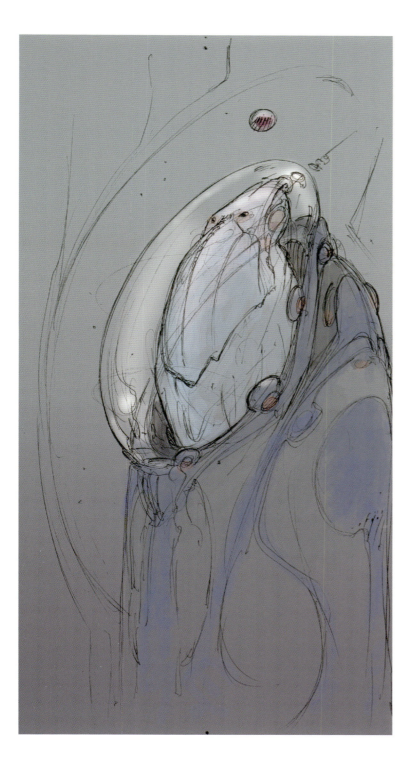

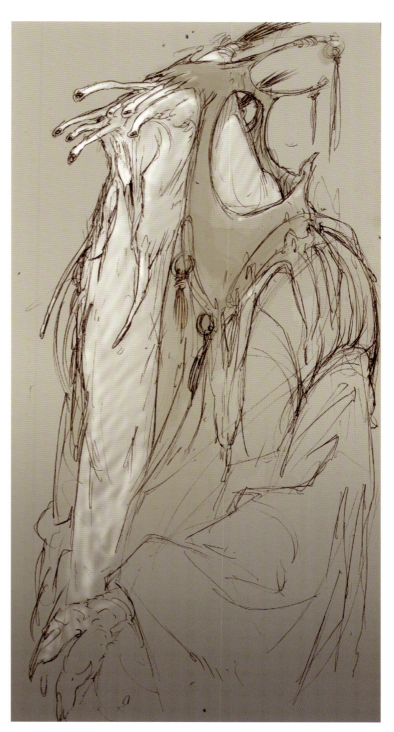

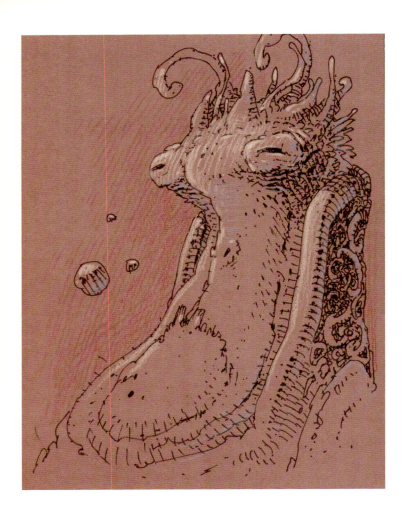

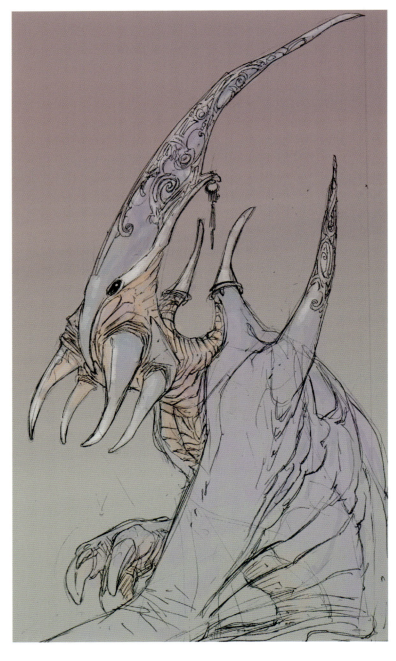

# ALIEN CONCEPTS

The creature on the right was done without initial sketches or specific thoughts. I just wanted to experiment in Photoshop and see where each brush-stroke would take me. I do that often; I think it's almost an urge to break away from doing so many concepts that have specific visual direction or idea. It's a healthy balance.

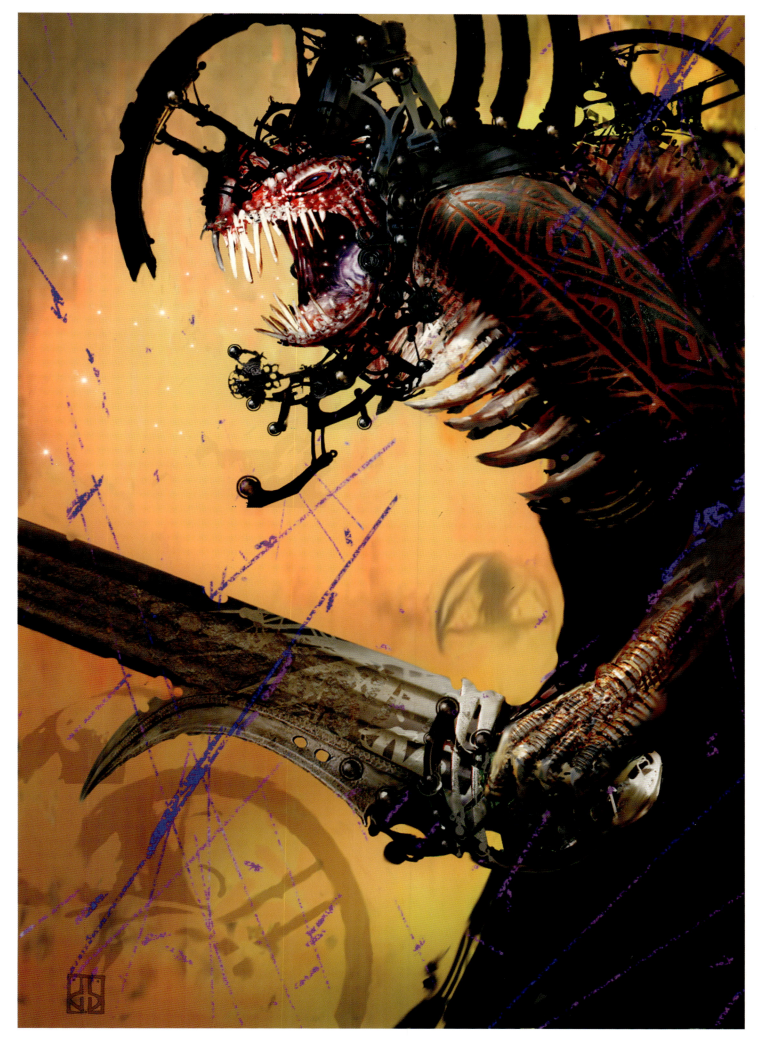

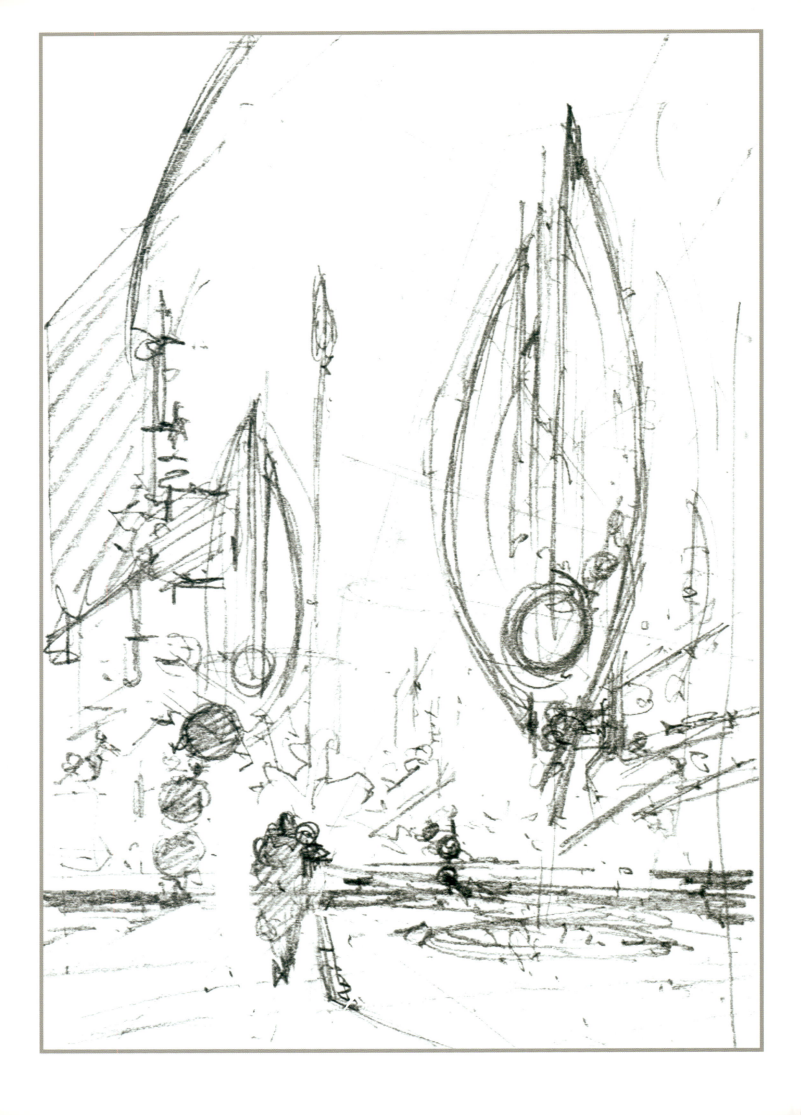

I built a painting by putting little marks together
—some look like hot dogs, some like doughnuts.

—*Chuck Close*

VARIABLE STAR | original sketch
**book cover** | written by Robert Heinlein and Spider Robinson

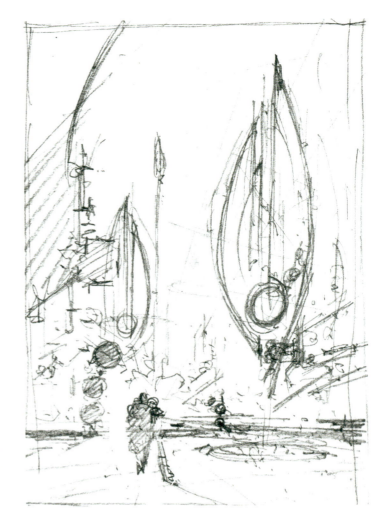

## 1 | sketch

In general, my sketches for book covers are very loose. I am more interested in the overall composition than the detail. Before long, I have a good idea about what these loose scribbles could be. Keeping the sketch loose also allows flexibility during the painting process. I can explore many possibilities and be surprised. It's an organic and creative process where the elements, details and nuances reveal themselves gradually.

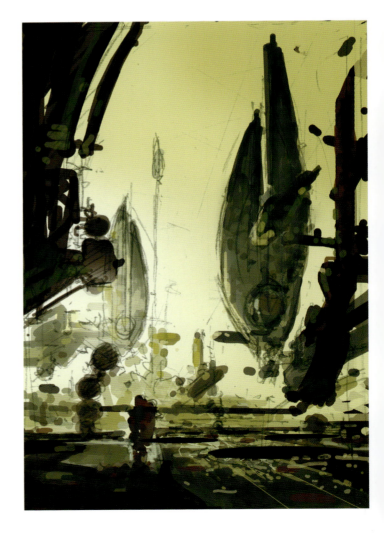

## 2 | color blocking

I always look for an image, or a series of images, as inspiration for mood and color. Once I have my reference selections I quickly block the colors. This defines the palette.

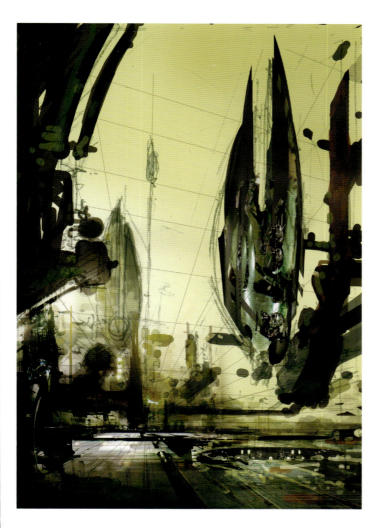

### 3 | perspective & depth

At this stage I set the perspective grid and start creating some depth by defining the structures in the background. I then place the ground plane. In this particular painting I decided to close the opening on the left to help direct the eye towards the center.

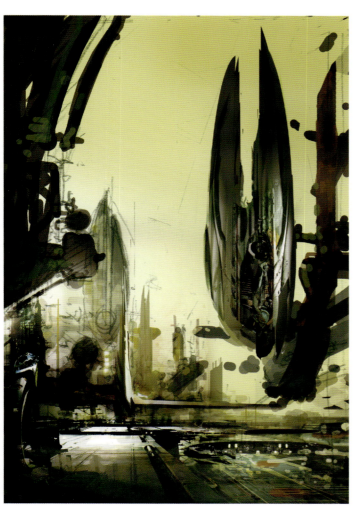

### 4 | light

Here I continued refining the structures in the background and adding depth by bringing light to the elements. At this point I already know that the main light source will come from the small ship that will be taking off in the center. I also start defining the shape and material of the big foreground ship, mixing and blending photo references and paint.

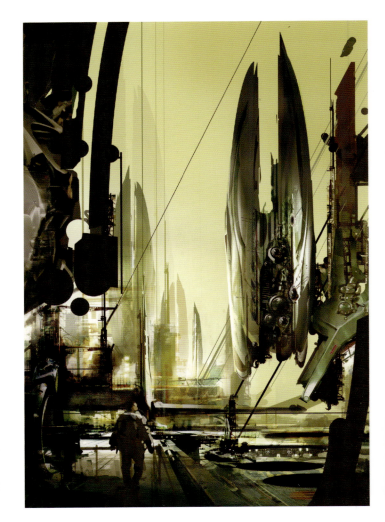

## 5 | refining the composition

Once the shape and curves of the foreground ship were in place, I realized that the curvature of the foreground structure needed to be adjusted to create a pleasant symmetry with the ship. I also added a curve in the lower right to balance out the upper left curve. I brought back the figure and started adding more details and light to the overall painting. I also introduced some diagonal lines. (The lower part of the launching ramp is a reused element from *Time Port 2*.)

## 6 | all in place

Bad idea for the diagonal lines! I removed them. I brought in the small ship taking off and started refining the areas receiving light from the blast. I also decided to bring a new ship into the background to help channel the smaller ship up. Now the painting began to come together.

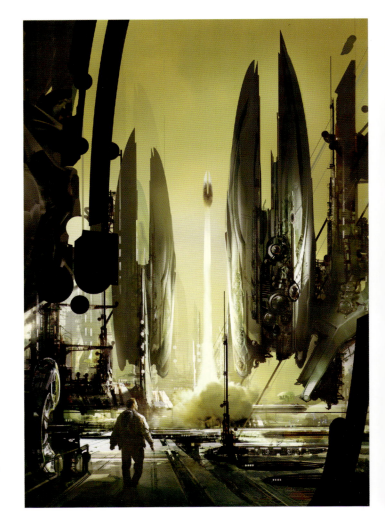

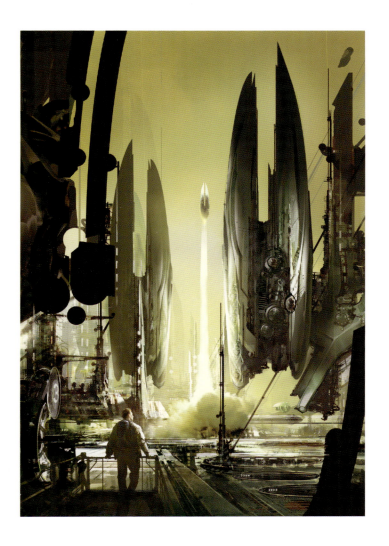

I decided to soften the background structure and tone down the blacks.

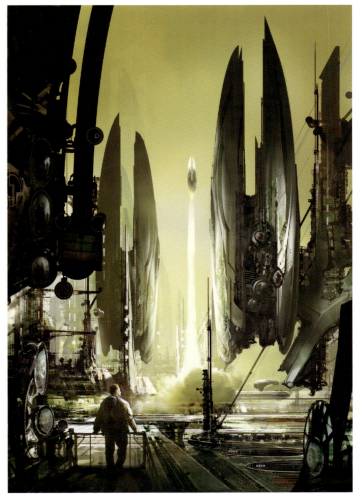

Now that all the elements are in place, I started adding the details in the foreground. The figure was still in progress.

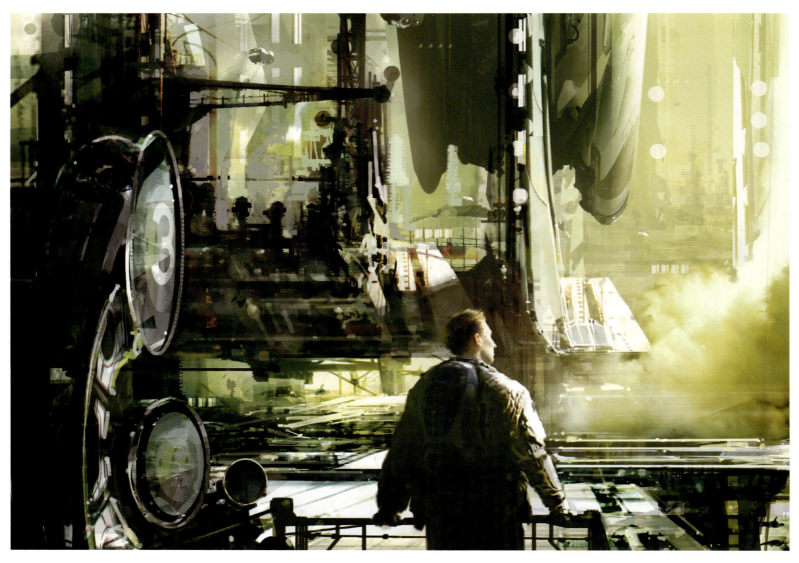

## 9 | finished painting

I added a few more touches: soft clouds, lights, and a touch more yellow overall ...*et voila!* I think this painting is a good example of how to create details using suggestive shapes. The overall impression may feel complicated, but in fact, all the details are quite simple. The background area to the left of the figure is the best example of this. The painting also demonstrates how to balance details against simplicity. Only a portion of the details for any given area is really necessary—the mind fills in the rest. I only had a feeling of what the painting could be when I started it. The references, the light and mood certainly gave me a sense of direction, but I definitely had no idea of the end result. This exploratory process of letting the painting progressively

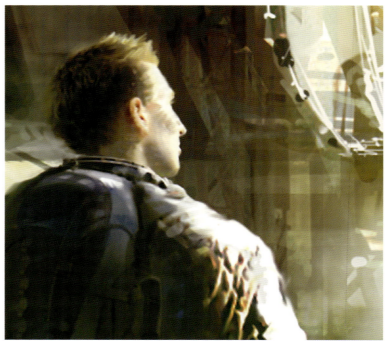

reveal itself is very creative, although at times the painting takes a while to come together. There are frustrations and sometimes doubts, but at the end it all fits together. This is not to say that I don't sometime have to scrap part of a painting or move in a different direction, but eventually the end result is always better than anything I could have imagined.

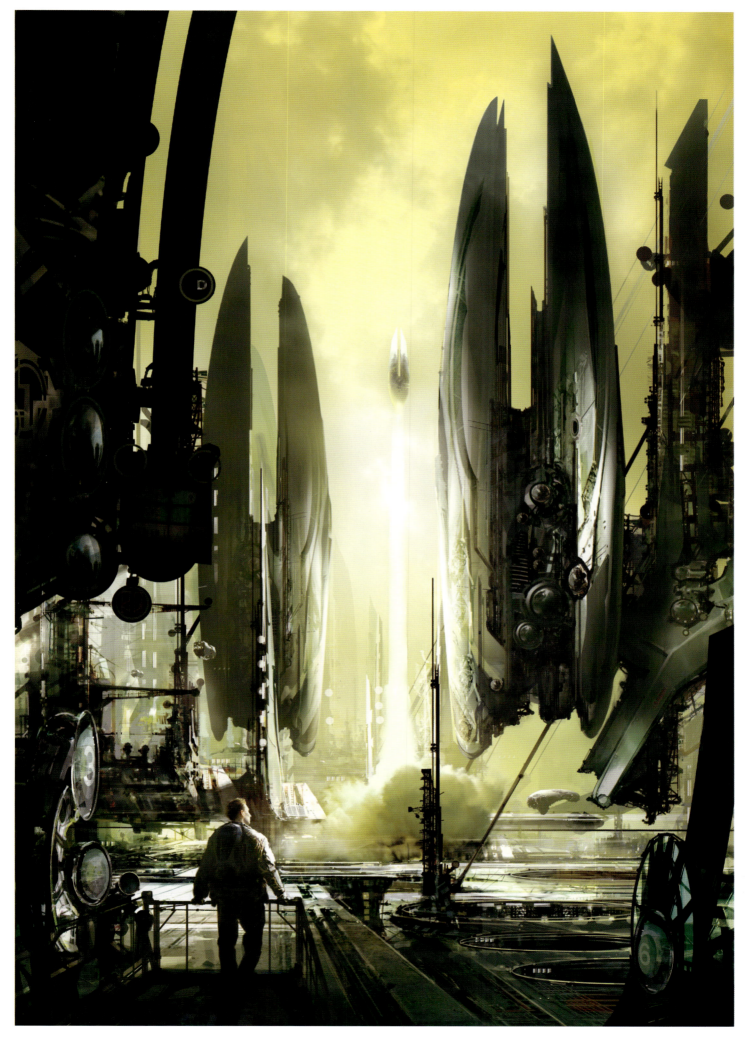

# other titles by design studio press:

**Start Your Engines:**
surface vehicle sketches & renderings
from the drawthrough collection
ISBN-13: 978-1-933492-13-1

**Lift Off:**
air vehicle sketches & renderings
from the drawthrough collection
ISBN-13: 978-1-933492-15-5

**Monstruo:**
the art of carlos huante
ISBN-10: 0-9726-6762-8

**Mas Creaturas:**
monstruo addendum
ISBN-10: 1-9334-9207-4

**Luminair:** techniques of
digital painting from life
ISBN 13: 978-1-933492-24-7

**Entropia:** a collection of
unusually rare stamps
ISBN-10: 1-933492-04-X

**LA/SF:**
a sketchbook from california
ISBN-10: 1-9334-9210-4

**The Art of Darkwatch**
ISBN-10: 1-9334-9201-5

**The Skillful Huntsman**
ISBN-10: 0-9726-6764-4

**In the Future**
ISBN 13: 978-1-933492-17-9

**Daphne 01:**
the art of daphne yap
ISBN-10: 1-9334-9209-0

**Worlds:** a mission of discovery
ISBN-10: 0-9726-6769-5  hardcover

**AVP:** the creature effects of a.d.i.
ISBN-10: 0-9726-6765-2

**Concept Design 2**
ISBN-10: 1-9334-9202-3

**Doodles:**
200 5-minute doodles
ISBN-13 978-1-933492-22-3

Buy the companion book
to *Quantumscapes*:

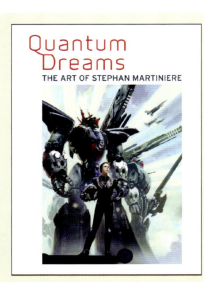

**Quantum Dreams:**
the art of stephan martinière
ISBN-10: 0-9726-6767-9

To order additional copies of this
book and to view other books we
offer, please visit:
**www.designstudiopress.com**

For volume purchases and resale
inquiries please e-mail:
**info@designstudiopress.com**

Or you can write to:
**Design Studio Press
8577 Higuera Street
Culver City, CA 90232**
tel 310.836.3116
fax 310.836.1136